Madness: A Very Short Introduction

VERY SHORT INTRODUCTIONS are for anyone wanting a stimulating and accessible way into a new subject. They are written by experts, and have been translated into more than 45 different languages.

The series began in 1995, and now covers a wide variety of topics in every discipline. The VSI library now contains over 500 volumes—a Very Short Introduction to everything from Psychology and Philosophy of Science to American History and Relativity—and continues to grow in every subject area.

Titles in the series include the following:

Andrew Scull

MADNESS

A Very Short Introduction

OXFORD
UNIVERSITY PRESS

OXFORD

UNIVERSITY PRESS

Great Clarendon Street, Oxford OX2 6DP

Oxford University Press is a department of the University of Oxford.
It furthers the University's objective of excellence in research, scholarship,
and education by publishing worldwide in

Oxford New York

Auckland Cape Town Dar es Salaam Hong Kong Karachi
Kuala Lumpur Madrid Melbourne Mexico City Nairobi
New Delhi Shanghai Taipei Toronto

With offices in

Argentina Austria Brazil Chile Czech Republic France Greece
Guatemala Hungary Italy Japan Poland Portugal Singapore
South Korea Switzerland Thailand Turkey Ukraine Vietnam

Oxford is a registered trade mark of Oxford University Press
in the UK and in certain other countries

Published in the United States
by Oxford University Press Inc., New York

First published 2011

British Library Cataloguing in Publication Data

Data available

Library of Congress Cataloging in Publication Data

Data available

Typeset by SPI Publisher Services, Pondicherry, India
Printed in Great Britain by
Ashford Colour Press Ltd, Gosport, Hampshire

ISBN: 978-0-19-960803-4

9 10

For Nancy, for putting up with my obsession with madness (and much else besides) for more than four decades. Te ador.

Contents

Acknowledgements

My debts to a host of other scholars, on whose labours a book
like this inevitably rests, are only inadequately hinted at in the
list of suggested further reading, and for that I must apologize.
The history of psychiatry as a field has flourished over the past
four decades, and I have benefited enormously from this
explosion of scholarship. Though it may seem invidious to
thank only a few individuals by name, some people have helped
me in so many ways over the years, as well as influencing my
thinking on madness, that it would be churlish not to
acknowledge them here. William Bynum, the best director the
late, lamented Wellcome Institute for the History of Medicine
ever had, and one of the most erudite medical historians
I know, has provided support, advice, and encouragement over
more years than I care to count. Michael MacDonald and Roy
Porter helped to open up new dimensions in my thinking on
matters psychiatric, as they did for so many others. Charles
Rosenberg, many years ago a colleague at the University of
Pennsylvania, and Gerald Grob, with whom I have had many
sharp exchanges in print for nearly as long, have been
unfailingly generous over the years. Among a younger
generation, my former student Nancy Tomes, and my friends
Akihito Suzuki and Joel Braslow, as well as my sometime

collaborators Jonathan Andrews and Nicholas Hervey, have kept me on my toes. Michael Shepherd, German Berrios, and David Healy, unusual psychiatrists all, also deserve my thanks. Above all, I owe more than I can say to my wife Nancy, to whom this book is dedicated.

Madness

List of illustrations

The publisher and the author apologize for any errors or omissions in the above list. If contacted they will be happy to rectify these at the earliest opportunity.

Madness

Chapter 1
Madness unbound

Qu'on ne dise pas que je n'ai rien dit de nouveau: la disposition de matèries est nouvelle

[Lest anyone is inclined to say I've said nothing new here: the arrangement of the materials is new.]

Pascal, *Pensée* 22 (1662)

Madness is something that frightens and fascinates us all. It is a word with which we are universally familiar, and a condition that haunts the human imagination. Through the centuries, in poetry and in prose, in drama and in the visual arts, its depredations are on display for all to see. A whole industry has grown up, devoted to its management and suppression.

And yet madness is no longer an acceptable term to use in polite company. For psychiatrists, its use is a provocation, an implicit rejection of their claims to expertise in the diagnosis and treatment of mental disorders, and symptomatic of a wilful refusal to accept the findings of modern medical science. For many of those suffering from serious disturbances of emotion and cognition, and for their friends and relations, it is an insult, a stigmatizing and hurtful anachronism that should be dead and buried, like the Victorian bins that once shut up so many of the lunatic in what at the time was pronounced to be a therapeutic isolation.

So the title of this *Very Short Introduction* is bound to provoke, to raise hackles, in some quarters to infuriate. And perhaps that is a good thing. For our subject is precisely something that profoundly disturbs our commonsense assumptions; threatens the social order, both symbolically and practically; creates almost unbearable disruptions in the texture of daily living; and turns our experience and our expectations upside down. Besides, this is a work of history, and till the last two centuries, 'madness' was a term widely and unselfconsciously employed by both sufferers and their would-be healers, as well as by society at large. If a once respectable word has now become linguistically taboo (except, ironically, among some of the mentally ill themselves, who defiantly embrace it as part of their rejection of the psychiatric enterprise), that very process is part of what I shall explore and comment upon here.

Madness is not a medical term (though it was once widely used by medical men). It is a commonsense category, reflecting our culture's (every culture's?) recognition that Unreason exists, that some of our number seem not to share our mental universe: they are 'irrational'; they are emotionally withdrawn, downcast, or raging; their disorderly minds exhibit extremes of incomprehensible and uncontrollable extravagance and incoherence, or the grotesquely denuded mental life of the demented. *Pace* the Thomas Szasz's of this world, who proclaim mental illness a myth manufactured by a malevolent medical profession, it is vital to acknowledge at the outset the havoc, the disturbance, and the disarray that madness produces, and the pain and suffering it imposes on the sufferer, the intimate social circle he or she moves in, and the larger society. Madness may be a social fact, as the French sociologist Émile Durkheim might say. Its manifestations, its meanings, its consequences, are most certainly deeply affected by the social and cultural context within which it surfaces and is contained. But it is emphatically not something created by social labels, save in a purely tautological sense. Nor, in

the final analysis, is it simply a social construct. Such romantic illusions will not inform the discussion that follows here.

Let us begin, then, with the recognition that madness – massive and lasting disturbances of behaviour, emotion, and intellect – resonates powerfully in our collective consciousness. Lunacy, insanity, psychosis, mental illness – whatever term we prefer, its referents are disturbances of reason, the passions, and human action that frighten, create chaos, and yet sometimes amuse; that mark a gulf between the commonsense reality most of us embrace, and the discordant version some humans appear to experience. Its existence has given birth to elaborate sets of social institutions and systems of knowledge that seek to comprehend, to contain, to manage, and to dispose of powerful symbolic and practical challenges madness poses to the social fabric and to the very possibility of social order.

As we shall see, social responses to madness, our interpretations of what madness is, and our notions of what is to be done about it, have varied remarkably over the centuries. On another level, the very seriousness of the challenges that madness represents have made lunacy a subject that has repeatedly attracted the attention of writers and artists, to say nothing of those who profess to possess a deeper understanding of its sources, its treatment, perhaps even its cure. It is those historically and culturally variable responses, and that deeper engagement with the existential meaning of madness, that will form the subject of this *Very Short Introduction*. My focus will be on the Western world, from the ancient Greeks to the present – a sort of 'Madness and Civilization', if you like, but not one viewed through a one-eyed Foucauldian lens. Madness in the Muslim world, in India, China, and Japan, in the colonial and post-colonial worlds – those are topics I shall touch upon lightly, if at all. We shall have more than enough with which to occupy ourselves without straying into those territories.

3

One further preliminary point: like many a commonsense term, 'madness' is somewhat imprecise. Just how bizarre or disruptive must someone's emotions or thought processes be before the label is invoked? Self-evidently, that varies across time and place, across lines of gender, class, and so forth, albeit in non-random and sociologically explicable ways. There are forms of alienation so extreme – perhaps we can call them 'Bedlam madness' for convenience, after the most famous madhouse in the English-speaking world – that they are unambiguous and obvious to all competent members of a given culture. But there are other varieties that hover on the borderlands, their status uncertain and contested. Are they part of a continuum of human psychopathology, or is there a sharp division observable here? Between madness and malingering, let us say, or between insanity and eccentricity, or between psychosis and neurosis? Historically, the verdict has varied. Here, I shall embrace and discuss such ambiguity, not deny or minimize it. And we shall have occasion towards the end of the discussion in this book to examine the peculiar edifice modern psychiatry has constructed to try to obfuscate and obscure the existence of continuing profound uncertainties about how to establish the boundaries between the mad and the sane.

For despite the fact that contemporary psychiatry seeks to promulgate a notion of madness as the external manifestation of a badly wired brain, the consequence of faulty biochemistry or an excess or deficiency of certain neurotransmitters, the process of drawing boundaries around the mad remains an uncertain and contested activity, the site of recurrent controversy that only occasionally has analogues in other branches of medicine. No X-rays, no PET scans, no laboratory tests exist that unambiguously pronounce that one is sane, this one mad. Despite the frantic and endlessly repeated efforts of the committees charged with writing and re-writing the Bible of psychiatric practice, the *Diagnostic and Statistical Manual of the American Psychiatric Association*, the boundary between sanity and

madness remains permeable and contested, and the pretensions to have cut nature at the joints in differentiating hundreds of types and subtypes of mental disorder are exactly that, an elaborately disguised game of make-believe. Just as, on a very different plane, the moral and social status of the mad and their doctors continues to occupy a very uncertain terrain.

Is madness all in the mind, a group of psychological disturbances to be understood (and perhaps largely treated) through talk, or manipulating the social-psychological environment of the mental patient? Is it, on the contrary, a somatic disease like any other, the manifestation of a brain and body gone awry? If the former, then perhaps madness has meaning, and reveals something central about ourselves and our very identity as human beings. If the latter, then aren't the mental symptoms that prompt some to seek help lest they 'lose their minds', and others to intervene to impose some organized and more or less exclusionary response on those perceived as a threat, nothing more than noise? Then the search for meaning is a fool's errand. Rather, we should commit ourselves to neuroscience and to unravelling the mysteries of the human brain.

The difficulty we confront in addressing such issues is twofold: on the one hand, of course, definitive answers to them remain remarkably elusive; and on the other, such antinomies may be badly framed, posing these issues as either/or questions, when reality may need us to see them as both/and formulations. There is no shortage of zealots who proclaim otherwise, and they are not a new phenomenon. Two centuries ago, one of Bedlam's doctors, William Lawrence, proclaimed that deranged thoughts 'have the same relation to the brain as vomiting, indigestion, heartburn, to the stomach, cough, asthma to the lungs, or any other deranged functions to their corresponding organs' (1816). By the late 19th century, with equal certainty, the professional consensus was that the mad and the mentally infirm were a biologically defective lot, their madness the product of deformed brains and inferior

heredity. In the first half of the 20th century, that led the United States Supreme Court, citing these established findings of medical science, to license the involuntary sterilization of the mentally ill and mentally defective. As Justice Oliver Wendell Holmes memorably phrased the principle, in dealing with a case of alleged lack of mental development, 'three generations of idiots are enough'. Not much more than a decade after that court decision, Hitler's Germany took such notions to their logical conclusion: with the active and enthusiastic participation of many German psychiatrists, mental patients were sent in their thousands to the gas ovens. (More than 70,000 were gassed in just 20 months, beginning in January 1940.)

By the end of the Second World War, however, the leading lights of American psychiatry were singing from a very different hymnbook, proclaiming that the 'refrigerator mother' was at the root of all the cases of schizophrenia jamming the wards of state mental hospitals. The most dreaded of the psychoses thus had psychological roots and (so it seemed to them) was curable by talk therapy, a process Hollywood proceeded to retail to the masses in films like *The Snake Pit* and *I Never Promised You a Rose Garden*. In a dazzling reversal of received opinion, our own generation of experts has once more embraced biological reductionism, but modern psychiatrists can't quite settle on what has gone haywire: genes, neurotransmitters, bad biochemistry of some other sort – and breathless proclamations that the conundrum has been solved simply fail to withstand scrutiny. With a few exceptions – the syphilis that once produced general paralysis of the insane; the dietary deficiency that gave rise to pellagra, and brought emotionally disturbed and demented patients into the asylum – the underlying mechanisms that drive people mad remain as elusive and unclear as ever. And the weapons we have to treat madness in its multitude of forms are still crude and rudimentary – at best capable of providing some symptomatic relief, not cure (the marketing copy of the pharmaceutical industry notwithstanding). A penicillin for disorders of the mind or brain remains a chimera.

If modern science and massive research programmes leave the aetiology of our schizophrenias and our bipolar disorders uncertain and mysterious, for our remote ancestors, the problem of how to account for (and cope with) the depredations of madness must have seemed even more daunting. Baffled by its presence, they often sought solace and explanation in the realm of the supernatural: the wrath of God (or the gods); possession by the Devil, or by evil spirits; bewitchment; the astrological influence of misaligned stars; sometimes even divine blessing or holy madness, for – perverse as it might seem – some forms of madness were interpreted in a favourable light. Even Socrates, in Plato's *Phaedrus*, seems to endorse the paradox: 'Our greatest blessings', he informs us, 'come to us by way of madness, provided the madness is given to us by divine gift.'

That was the nub of the matter, of course. For the spiritually enraptured, those who spoke in tongues, produced oracular utterances, and foretold the future, could equally well find themselves being viewed as out of their minds by those who did not accept that they were divinely inspired, as in 1 Corinthians 14:22–23. In related fashion, the notion that melancholy and genius might be closely allied had a pedigree that reached at least as far back as Aristotle (who numbered Hercules, Socrates, and Plato among the ranks of those so blessed and cursed). As a cultural trope, such notions would be given perhaps their fullest articulation in the work of the Renaissance scholar Robert Burton, *The Anatomy of Melancholy*.

Madness surfaces repeatedly in religious texts and practices. The Hebrew Bible is replete with stories of those bereft of their wits, raving, frenzied, or thrust into the depths of melancholy. In the Book of Daniel, Nebuchadnezzar, who had laid siege to Jerusalem and destroyed its temple, loses sight of who the real ruler is. In the midst of his boasts about his accomplishments, God teaches him the necessary lesson by reducing him to a bestial form of madness. As we learn from a clay tablet preserved in the British Museum,

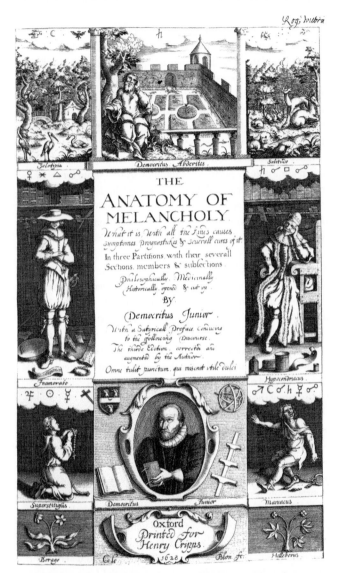

1. The title page of the 1638 edition of Robert Burton's *The Anatomy of Melancholy*, first published in 1621. A sprawling treatise, it ran to 900 quarto pages in its first published form

during seven long years, 'his life appeared of no value to him...he does not love son or daughter...family and clan does not exist'. Or, in the biblical version (Daniel 4:13), 'Let his heart be altered from that of a man, and let him be given the heart of a beast, and let seven seasons pass over him.'

In Samuel (1 Sam. 15:1–3, 8–9), Saul, the King of the Jews, rebels against God, failing to carry out to the letter divine instructions to slaughter the Amalek, 'both man and woman, infant and suckling, ox and sheep, camel and ass....and spare them not'. Though he 'utterly destroyed all the people with the edge of the sword', he spared their king, Agag, and he spared 'the best of the sheep, and of the oxen, and of the fatlings, and the lambs, and all that was good, and would not utterly destroy them'. He was accordingly denounced by the prophet Samuel for his defiance of God. And shortly thereafter, so we are informed, 'the Spirit of the Lord departed from Saul, and an evil spirit from the Lord tormented him'. By turns fearful, raging, homicidal, and deeply melancholic, he languished for the rest of his rule in a state of intense mental turmoil, ending only with his self-inflicted death on the battlefield, where he faced certain defeat (presumably because of continuing divine displeasure) (1 Sam. 31). Prophets and mystics might alternately be regarded as intensely religious or as mad, as in Jeremiah (29:26). Indeed, as George Rosen has noted, the Hebrew for 'to behave like a prophet' can also be rendered as 'to rave' or 'to act like one beside himself'.

In the New Testament, there are still more vivid accounts of madness conceived of as possession, with Christ regularly pictured as casting out the demons (seven, so we are told, from Mary Magdelene alone (Mark 16:9; Luke 8:2–3)). On one notable occasion, Jesus is reported to have caused them to transmigrate into a herd of swine: 'and, behold, the whole herd of swine ran violently down a steep place into the sea, and perished in the waters' (Matthew 8:32). With these divine precedents, prayer and exorcism were one remedy canvassed for cases of insanity among

Christians, and suitable rites were accordingly made up by the Church to permit priests to cast out the Devil and his minions.

Madness is equally a staple of Homeric myth and of Greek drama. (Not for nothing would Freud dub the primal event in the formation of the human personality the Oedipus complex.) The machinations of the gods, but also the agonies of guilt and responsibility, the conflicts thrown up by duty and desire, the unshakeable effects of shame and grief, the demands of honour and the disastrous impact of hubris – in the dramas of Sophocles, of Euripides, and of Aeschylus, all too often these provoke the furies of madness: a rampaging Medea slaying her children; Heracles, foaming at the mouth, eyes rolling in their sockets, thinking he is killing Eurystheus's children, but in reality dispatching his own; everywhere frenzy, anger, violence, and destruction stalk the stage. Here are images of immense power to shock, to provoke, to illuminate, even to provide emotional catharsis. They mark a literary and artistic fascination with madness that will persist throughout its long history.

Almost simultaneously, however, other Greek thinkers were developing a very different perspective on madness, one that emphasized its natural roots in disorders of the body. We used to speak in uncomplicated fashion of Hippocrates (c. 460–357 BCE) as the founding figure of the Western medical tradition, one whose writings were the source of a view of the origins of health and illness that would persist for more than two millennia. Nowadays, we more properly speak of the Hippocratic tradition, recognizing that the texts once attributed to one great man came from many hands, and a number of them were written down many years after Hippocrates' death. But the model of sickness and its treatment outlined in these pages, modified to be sure by other Greek and Roman authorities, most especially Galen of Pergamum (131–201 CE), would become the ruling orthodoxy among the educated classes (and in bowdlerized forms among *hoi polloi*) until the very end of the 18th century and perhaps beyond,

and the dominant ideology of those who proclaimed themselves doctors of medicine.

As modified by Galen, the Hippocratic system embodied what came to be a very broadly shared set of cultural understandings about the nature of disease and its therapeutics. At its core was the claim that the body was a system of inter-related elements that were in constant interaction with its environment. The system, moreover, was tightly linked together, so that local lesions could have generalized effects on the health of the whole. Each of us was composed of four basic elements which contended for superiority: blood (which made the body hot and wet); phlegm (which made the body cold and wet, and was composed of colourless secretions like sweat and tears); yellow bile or gastric juice (which made the body hot and dry); and black bile (which made the body cold and dry, and originated in the spleen, darkening the blood and stool). The varying proportions of these humours with which an individual was naturally endowed gave rise to different temperaments. But their balance was also susceptible to being thrown out of whack by a variety of influences: seasonal variation and developmental changes over the course of the life cycle, as well as a host of other potential sources of disturbance. Bodies assimilated and excreted, and thus were affected by such things as diet, exercise regimen, and sleeping patterns, and by emotional upsets and turmoil. There was, in other words, a clear recognition at the heart of this whole intellectual edifice that upset bodies could produce upset minds, and vice versa. The key to good health was keeping the humours in equilibrium, and when the patient fell ill, the physician's task was to deduce what had become unbalanced and to use the therapies at his disposal to readjust the patient's internal state. Body and environment; the local and the systemic; *soma* and *psyche*: each element of these dyads was capable of influencing the other, and of throwing the individual into a state of disease. Hippocratic medicine was, in every sense, a holistic system, one that paid close attention to every aspect of the individual patient,

and tailored therapeutic regimes to each case. And, most importantly, it was a view of human health that emphasized the natural, rather than the supernatural, causes of disease.

As an intellectual construct, the humoral theory of disease was immensely powerful, making sense of symptoms, and pointing the way towards remedies for what had gone wrong. It simultaneously provided reassurance to the patient, and an elaborate rationale for the interventions of the physician. The Hippocratics did not emphasize human anatomy, save for their close attention to the external appearance of the body, and they actively avoided dissecting corpses, something that was almost taboo within Greek culture. Even the Roman physician Galen relied upon dissecting animals for his view of the way bodies were put together, so that mistaken views of human anatomy persisted in medical circles well into the Renaissance. But the Hippocratics' rejection of the notion that either magic or divine displeasure played any role in the causation of disease was fierce and unambiguous, and their holism, and stress on the role of the psychosocial as well as the physical in bringing about ill health, encouraged them to proffer thoroughly naturalistic accounts of madness, alongside their explanations of other forms of sickness – indeed, to draw no sharp distinctions between the two.

There was much else to encourage a common approach to madness and more unambiguously physical disease. Distortions of perception, hallucinations, emotional upset and turmoil are frequent concomitants of being seriously ill. 'Fevers', which we regard as symptoms but which for centuries were seen as the disease itself, could have a multitude of sources, particularly in an era when infectious and parasitic diseases were rife. And the delirium and altered consciousness, the raving and the agitation, that were fever's frequent concomitants often resembled the disordered thinking of the mad. Many people had encountered (or deliberately sought) the cognitive and emotional disturbances that ingesting too much alcohol or partaking of other mind-altering

substances brings in its train. And virtually everyone, then and now, had experienced moments of extreme psychological anguish, suffering, and pain. Emotional and cognitive dysfunctions were (as they remain) a familiar part of human existence, though for most of us, mercifully, a transient one. The analogies to madness were hard to miss, and the Hippocratics insisted that both had their origins in the underlying make-up of the human frame.

Where Aristotle had seen the heart as the seat of the emotions and of mental activity, Hippocratic texts saw the brain as their centre:

> men ought to know that from nothing else but the brain come joys, delights, laughter and sports, and sorrows, griefs, despondency, and lamentations. And by this in an especial manner, we acquire wisdom and knowledge, and see and hear, and know what are foul and what are fair, what are bad and what are good, what are sweet and what unsavoury...

If it was the head, not the heart, which ruled, the encephalon was also where madness lurked:

> It is the brain too which is the seat of madness and delirium, with the fears and frights which assail us often by night but sometimes even by day; it is there where lies the cause of insomnia and sleep walking, of thoughts that will not come, forgotten duties and eccentricities. All such things result from an unhealthy condition of the brain... when the brain is abnormal in moisture it is necessarily agitated.

And, as with other forms of ill health, the problem lay in an imbalance of the humours: too much blood led to warming of the brain, and hence to nightmares and terrors; too much phlegm might produce a mania whose victims

> are quiet and neither shout nor make a disturbance... [while] those whose mania results from bile show frenzy and will not keep still, and are always up to some mischief.

The very term 'melancholy' derives from the Greek word for black (*melan*) and the word for bile (*chole*). Hence depression as a black mood.

The Greeks and the Romans thus bequeathed both natural and supernatural accounts of the ravages of madness to subsequent generations. And rather than a single undifferentiated condition, those who wrote on the subject had distinguished a number of different varieties of the disorder. Whether these were distinct from one another or merely phases through which distraction might pass was the source of some debate, but a broad differentiation between mania and melancholia had been established and would persist through the centuries. There were still other variant forms of madness that existed on the borderlands of insanity. There was epilepsy, whose dramatic seizures were often preceded and followed by mental upset – a disorder whose victims included Julius Caesar. Here, too, there was no consensus on what was going on. Many called epilepsy 'the sacred disease'. As a Hippocratic text of this title scornfully noted:

> Men regard its nature and cause as divine from ignorance and wonder, because it is not at all like to other diseases…it appears to me [however] to be nowise more divine nor more sacred than other diseases, but has a natural cause [blocked phlegm] from which it originates like other affections.

Still another variant form of madness discussed by the learned was hysteria, characterized by fits, choking sensations, and mental aberrations – a disorder of women that some saw as a form of possession, and others viewed as still another illness brought on by the peculiarities of the female constitution, her moister, looser, more fragile body, and, most especially, her rampaging womb.

These distinctions and debates would begin to resurface centuries later in medieval and early modern Europe, but in the interim, in the West at least, the classical legacy was all but lost. For Greek

and Roman writings – poetry, drama, histories, medicine – largely vanished from the scene in the aftermath of Rome's decline and fall. Absent print as a means of preserving and readily disseminating knowledge, the transmission of classical culture depended upon the preservation and onerous reproduction of fragile manuscripts, and the continuity of an urban leisured culture that simply failed to persist. In the words of the great historian of late antiquity Peter Brown, in the West, 'classical culture went by default … [and but for developments elsewhere,] we should know nothing – except from fragments in papyrus – of Plato, Euclid, Sophocles and Thucydides'.

All, that is, might easily have been irretrievably lost had not some numbers of classical texts and a semblance of the old traditions survived in the East, first in the Byzantine Empire centred in Constantinople, and later, after the triumph of Islam, among Arab scholars and in the increasingly vigorous medical community that emerged in the lands under Islamic dominion. Here, to a large extent, was where Greek and Roman learning was preserved and argued about, translated into the vernacular, and then, centuries later, translated back from Arabic, Syriac, and Persian into Latin. By this circuitous route, from the late 11th century onwards, much of classical learning and, most importantly in the present context, ancient Greek medical ideas, attracted renewed interest in the West. Centuries later, they would constitute an increasingly important element in the debate over the origins and treatment of madness that would gain prominence in the Renaissance and early modern Europe.

Not that the problems posed by mental illness waited upon the revival of classical learning, or the interventions of a reviving humoral medicine. Medieval society still faced on a practical level the question of how to manage the mad, and continued to place primary responsibility for caring and coping with them, as best we can tell (for the surviving evidence is fragmentary and incomplete) on the family, and to a far lesser extent, the Church. The lunatic,

that is, were left at large, their fate, like other largely dependent and helpless elements in society, at the mercy of whatever expedients their relatives could contrive, and of a haphazard and often ineffectual tradition of Christian charity and almsgiving.

Within the moral thought of the medieval Church, poverty, particularly if it were voluntarily assumed, was a position invested with considerable religious status and meaning, and charitable giving was urged on all good Christians. But neither the Church nor private individuals made any serious effort to match aid to need, though the great monastic foundations played a considerable role in the care of the unfortunate. A measured, calculated response to various forms of human misery was clearly foreign to a society where the impulse to give was governed largely by the desire to secure one's own salvation. And besides, these were societies for which the margin between subsistence and starvation was narrow, and where famine, disease, violence, and early death were everywhere a looming threat. Madness was just one of a whole catalogue of misfortunes that threatened health and happiness.

Where families had the resources, the responsibility for the custody of the lunatic, guarding both their distracted relative and the community from harm, fell on their shoulders. Sometimes, the community might provide some temporary or permanent assistance to help them cope. If those expedients failed, then madmen might be left to their own devices. The deranged beggar, like the leper, was a familiar part of the medieval landscape, wandering from place to place, community to community, in search of alms. Shakespeare would make use of the enduring and iconic image of such Toms o' Bedlam in *King Lear*, where the outcast Edgar disguises himself as mad, in other words,

> '. . . the basest and most poorest shape
> That ever penury in contempt of man
> Brought near to beast. My face I'll grime with filth,

Blanket my loins, elf all my hair in knots,
And with presented nakedness outface
The winds and persecutions of the sky.
The country brings me proof and precedent
Of Bedlam beggars, who, with roaring voices...
Enforce their charity.'

But charity could not be 'enforced', of course, and while some have conjured up romanticized images of the fate of the mad left at large, and of the Middle Ages as an era when madness was seen as part of the continuum of human existence, there was little solace to be gained from the freedom to roam or rot. Not shut up, the life of the poor and mad, dependent and a burden, was almost certainly a Hobbesian existence: nasty, brutish, and short.

Matters might at certain times take an even nastier turn. Many forms of illness were seen as the result of moral failings or lapses, or the vengeance of a displeased God – a notion that persisted as a respectable belief as late as the 19th century, when divines proclaimed that epidemics of cholera were a sign of divine displeasure at the sinful state of society, and both the British Parliament and the American Congress called for national days of prayer and repentance to ward off God's punishment. The Plague that carried out so large a fraction of the European population in the 14th century understandably was interpreted in this fashion, and madness likewise could readily be seen in supernatural terms – even by some of its victims, whose delusions often assumed such forms. Often, though by no means always, in a spirit-drenched world, where popular beliefs in devils and witchcraft were fervently held, the consequences could prove dire: the mad or those deemed to have cast spells on them to drive them to distraction might find themselves caught up in the mania for witch-hunting that periodically erupted in one community or another in a credulous Europe, and then they risked being cast into the flames. Thousands perished, and though by no means all witches were the mentally ill (or those blamed for fomenting

mental illness), still ancient folk beliefs about madness and possession (which had, as we have seen, some biblical sanction) always created that danger.

Speaking of 'Bedlam beggars' reminds us that the term was coined from the name of the most famous asylum in the English-speaking world: Bethlem (originally Bethlehem) Hospital, a monastic foundation dating from the 13th century that had begun to attract a handful of mad inmates from the late 14th century, and eventually came to specialize in the care of the insane. Hospitals were another institution that the Europeans had borrowed from the Arab world, and re-dressed in Christian garb. The Hotel Dieu in Paris, the Santa Maria Nuova in Florence, and St Bartholomew's Hospital in London are all examples of such medieval foundations. In Spain, which had only gradually emerged from centuries of Islamic rule in the 12th and 13th centuries, there were as many as seven hospitals founded in the 15th century that, like Bethlem, came to specialize in the institutional confinement and care of the insane: in Valencia, Zaragoza, Seville, Valladolid, Palma de Mallorca, Toledo, and Barcelona.

Bethlem became so closely associated with the history of madness in centuries to come that allusions to it in a medieval context can easily mislead, especially when one acknowledges the emergence of a handful of comparable establishments elsewhere. In reality, it was an insubstantial, noisome place, poor, dirty, and tiny. In 1598, for instance, it contained only 20 inmates, a number that remained essentially stable for another half century and more. So its mere existence, and its later size and prominence, should not prompt any sense that institutional responses to madness were anything other than rare and exceptional even as late as the 17th century.

Early hospitals, of which Bethlem was one, were predominantly religious, not medical establishments (the word comes from the same root as 'hospitality'), and they served predominantly as way-stations for pilgrims and places of respite for the needy.

A number of them may have coped with the occasional mad inmate from time to time, and Bethlem's gradual specialization in confining the insane was essentially a matter of pure chance, though serving as a lunatic asylum soon became its entrenched role. It was primarily a place of confinement in these years, one that, in Thomas More's words, made use of 'betynge and correccyon'. An Indulgence issued in 1446 had already made clear that the 'miserable persons dwelling there...are so alienated in mind and possessed of unclean spirits that they must be restrained with chains and fetters'. Beyond such tantalizing glimpses, however, much about the treatment meted out at Bethlem in these years remains speculative and opaque. At best, our knowledge is fragmentary, though we can say with some confidence, echoing the hospital's official historians, that 'there is very little evidence of formal arrangements to provide anything which, even on the most generous assessment, could be termed medical help'.

As the medieval world drew to a close, European societies continued, as they had for centuries, to grapple with madness in a variety of overlapping, often contradictory ways. That heterogeneity would persist long past the dawn of the modern age. But the 17th century would witness the beginning of a much greater fixation on the problems and meanings of madness, a heightened attention that quite early on manifested itself in the worlds of art, drama, and literature, and soon could be seen to surface in the world of practical affairs.

Chapter 2
Madness in chains

If we are to judge from its place in the literary and plastic arts, madness seems to have acquired a much greater cultural salience than hitherto in the period between the Jacobean age and the dawn of the 19th century. Playwrights of the late 16th and early 17th centuries made frequent allusions to Bethlem and its mad inhabitants. On the Restoration of the Stuart dynasty in 1660 following the idol-smashing puritan years of Cromwell's Commonwealth, and in the immediate aftermath of the depredations of the Great Fire of London in 1666, Bethlem itself was rebuilt, moving from a dilapidated and boxed-in site in Clerkenwell to a prominent place in Moorfields, just north of the ancient heart of the city. Here, on a suitably liminal site, the filled-in ditch that ran alongside the old city wall, the Renaissance polymath Robert Hooke (who, together with Christopher Wren had designed the Monument to the Great Fire itself) created a spectacular new palace intended to display the benevolence and solicitude of London's citizens, to symbolize the Restoration of royal and civic unity, and to connect the rule of the Stuarts to the restoration of the rule of reason. Bethlem Hospital launched a new moral architecture of madness, and over its gates were erected two emblematic statues, Raving and Melancholy Madness, by the Danish sculptor Caius Gabriel Cibber.

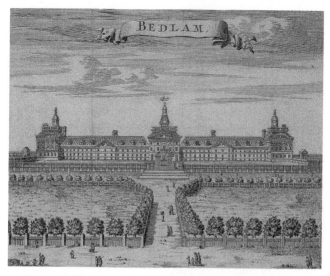

2. The new Bethlem Hospital in Moorfields, designed by Robert Hooke, and opened in 1676, a celebration of the Restoration of the Stuart monarchy in 1660, and with it, the rule of reason

A half century later, one of Hogarth's best-known satirical prints would be set in its cells, a stylized precursor in its turn of Goya's unforgettable rendering of the hellish interior of a madhouse.

As we move from the medieval to the modern world, in plays, in broadsides, and in ballads, in the pages of *Don Quixote*, and in the pioneering novels and pulp fiction of 18th-century England (from Smollett and Richardson to the authors of the first gothic tales), a fascination with madness is visible everywhere. In the written word; on the stage; in political pamphlets; in songs heard on the street; in architecture and sculpture; in painting and in the new mass-produced engravings: images of Unreason surface. Madness re-imagined emerges in a plethora of places, replete with portraits of barely contained violence and terminal despair, of chains, whips, and beatings, of confinement in barred cells run by

ruffianly keepers, whole scenes that embrace the loss of reason among some who externally remain facsimiles of normal human beings, but who in fact have descended into, or even beneath, the ranks of the beasts.

Shakespeare makes madness a central theme in some of the greatest of his plays. *Lear* provides us with a Fool whose mental state licenses him to tell truths saner mortals dare not utter; another character, as we have already seen, who deliberately disguises himself as a madman and wanders naked through the countryside; and the king himself, pleading 'O, let me not be mad, not mad, sweet Heaven! Keep me in temper; I would not be mad!' – and mad becoming, as Fate and his own foolishness bring successive hammer blows upon his head. Hamlet's behaviour – bullying and betraying poor Ophelia, pretending to love her and scorning her, then killing her father – drives her out of her wits. She becomes a pitiable creature,

> Divided from herself and her fair judgement
> Without which we are pictures [i.e., mere facsimiles of a human being] or mere beasts.

The chaste maiden thus reappears on stage singing bawdy and mad songs and speaking in riddles, then disappears, wandering down by a river bank and clambering on to the branch of a willow, whence she

> Fell in the weeping brook. Her clothes spread wide
> And, mermaid-like, awhile they bore her up; ...
> Till that her garments, heavy with their drink,
> Pull'd the poor wretch from her melodious lay
> To muddy death.

If Ophelia becomes an iconic figure of a woman driven mad by mistreatment and loss (her drowning re-imagined by Millais two

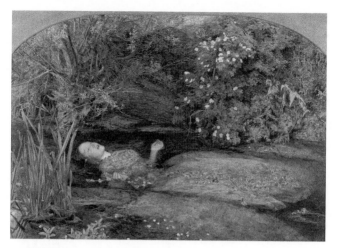

3. *Ophelia*, by Sir John Everett Millais (1829–96). This painting of Ophelia still afloat, singing her mad songs, aroused controversy and harsh criticism as an affront to popular taste when first exhibited in 1852. In the words of the reviewer for the *Atheneum*: 'There must be something strangely perverse in an imagination which souses Ophelia in a weedy ditch, and robs the drowning struggle of that lovelorn maiden of all pathos and beauty, while it studies every petal of the darnel and anemone floating on the eddy.'

and a half centuries later in one of the most famous of the Pre-Raphaelite paintings), what then of Hamlet himself? His creator makes of him the very model of ambiguity and uncertainty, Hamlet's irresolute waverings and inability to act mirror our uncertainty as his audience about his very sanity. Is he play-acting? After all, he tells his friends he may have occasion to 'put an antic disposition on', and he insists, when others doubt his sanity, 'I am but mad north-north-west: when the wind is southerly I know a hawk from a handsaw'. But his introspective melancholy, his meditations on suicide, his inappropriate and blunted emotional responses – to Ophelia's death and much else besides – suggest that his madness is more than merely feigned. For Shakespeare's contemporaries, as other historians have noted,

the issue may have been moot. A number of them have argued that audiences when the play was first presented may well have taken it for a straightforward revenge tragedy. But by the early 18th century, and most certainly ever since, the issue of the status of the prince's 'madness' has been recurrently a matter of debate. Not so Lady Macbeth, unhinged by the consequences of her vaulting ambition and its murderous enactment:

> Out, damned spot! Out I say...who would have thought the old man to have had so much blood in him?...Here's the smell of the blood still. All the perfumes of Arabia will not sweeten this little hand.

Her mind is fatally infected, and 'More needs she the divine than the physician'.

Images of madness were a familiar sight elsewhere on the Elizabethan and Jacobean stage: in Marston's *What You Will* ('Shut the windows, darken the room, fetch whips: the fellow is mad, he raves – talks idly – lunatic') and in Shirley's *Bird in a Cage* (in which the madhouse is referred to as 'a house of correction to whip us into our senses'), in Thomas Decker's *The Honest Whore*, Fletcher's *The Pilgrim*, and Middleton's *The Changeling*. Indeed, it was the commonplace character of these associations that allowed writers not only to employ them to arouse terror, pity, and disgust, but also to make use of them for satiric and comic effect. Shakespeare, of course, was not slow to exploit these dramatic possibilities, as when the disguised Rosalind teases the love-sick Orlando in *As You Like It*:

> Love is merely a madness; and I tell you, deserves as well a dark house and a whip as madmen do; and the reason why they are not so punished and cured is, that the lunacy is so ordinary that the whippers are in love too.

Or, in a variation on the same theme, when Theseus in *A Midsummer Night's Dream*, informs Hippolyta that:

24

Lovers and madmen have such seething brains,
Such shaping fantasies, that apprehend
More than cool reason ever comprehends.

But it was *Don Quixote* that provided their most sustained and hilarious instantiation, its first instalment appearing just as *Lear* received its first public performance. Mad Quixote clearly is, obsessed and hallucinating, incapable of perceiving the world as others see it. His craziness is perceived and mocked, even assaulted, by those around him. And tormented he equally is, physically in Part One of his adventures, and psychologically in its sequel. Here was a mock-heroic masterpiece featuring our would-be knight errant famously tilting at windmills and fighting with sheep, sheep that the mad Quixote transforms into two onrushing armies: 'He rushed madly this way and that. The sheep were routed and trampled upon in a most terrible manner.' And then the shepherds, protecting their flocks, turn on him, pelting him with stones and tumbling the bleeding Quixote from his saddle. When Sancho Panza reproaches him for assaulting the poor beasts, Quixote insists they were indeed armies of soldiers, and that 'at the very moment that my victory was complete, my old enemy changed the routed army into a flock of sheep. It was all done to rob me of the glory that belonged to me.'

Cervantes' world of folly would find its anglicized echo a century and a half later, in Tobias Smollett's *Sir Launcelot Greaves*, a novel that ends with both hero and heroine trapped in a madhouse run by the eponymous Bernard Shackle. Madness was now a territory that writers in a variety of genres continued to exploit and explore. Growing affluence and literacy spawned much greater audiences for fiction, and sentimental novelists were not slow to take advantage of the commercial opportunities that now opened up. Henry MacKenzie, one of the prime exponents of this mawkish but lucrative market, promptly sent one of his most popular heroes on a visit to Bethlem, where the sight of the poor lunatics prompted one of those floods of tears that the author of *The Man*

of Feeling repeatedly inflicted on his readers. And still further down-market, the gothic novel made its debut, one of its stock plot devices involving the confinement of the innocent hero (or preferably heroine) in the cells of a madhouse, presided over by unscrupulous ruffians.

From Eliza Haywood's *The Distress'd Orphan, or Love in a Madhouse* (which first appeared in 1724 and stayed in print till the end of the century), through Mary Wollstonecraft's *Maria; or, the Wrongs of Women* (which was published in 1798), madhouse scenes were almost *de rigueur*, posing titillating threats to both the chastity and the sanity of the women corruptly consigned to this sort of living tomb. Annillia, Haywood's heroine, having refused to marry her cousin and give him her fortune, is carried off by her uncle's minions 'in the dead of night' to one of these establishments. Here this genteel and virginal creature finds herself among the Bedlam mad:

> The rattling of Chains, the Shrieks of those severely treated by their barbarous Keepers, mingled with Curses, Oaths, and the most blasphemous Imprecations, did from one quarter of the House shock her tormented Ears; while from another, Howlings like that of Dogs, Shoutings, Roarings, Prayers, Preaching, Curses, Singing, Crying, promiscuously join'd to make a Chaos of the most horrible Confusion.

Minor poets like Thomas Fitzgerald drew a contrast between the 'stately Fabric' of the new Bethlem and the disorder that reigned within:

> Woe and Horror dwell for ever here...
> And Peals of hideous Laughter shock the Ear.

And within the confines of a very different genre, Alexander Pope and Jonathan Swift found few figures as well suited as the lunatic to serve as the focus of their satires. While Pope warned of a world

about to be overwhelmed by dunces, in a characteristically excremental outpouring, Swift urged the madhouse keeper to stick to his task of reining in the mad:

Tie them keeper in a tether,
Let them stare and stink together:
Both are apt to be unruly,
Lash them daily, lash them duly,
Though 'tis hopeless to reclaim them,
Scorpion rods perhaps may tame them.

Meanwhile, on Grub Street, the Ned Wards of the world, journalists on the make, retailed the standard literary clichés, as they entertained their audience by providing what purported to be naturalistic descriptions of the antics of the Bedlamites:

such a rattling of chains, drumming of doors, ranting, holloaing, singing, and rattling, that I could think of nothing else but Don Quevado's vision where the damned broke loose and put Hell in an uproar.

It was Bethlem, indeed, that dominated 18th-century portraits of lunacy, verbal and visual. Foreign and domestic travellers both made a point of visiting it. It had already acceded to a status it has never relinquished, the mythical and mystical Bedlam of our imaginings: the scene of riot, turmoil, and tumult – a veritable (or perhaps not so veritable – for many Bethlem legends have little foundation in fact) theatre of folly, where Reason wrestled with the demons of Unreason in a continuing drama of brutal beatings and callous cruelties. Most famously, Bethlem featured as the climax of William Hogarth's didactic series of panels on the wages of sin, *A Rake's Progress*. Young Tom Rakewell, having suddenly come into a fortune, spends wildly on drink, fine clothes, and prostitutes. A series of paintings vividly captures his dissipation and decline, till the eighth scene presents us with the consequences of his debauchery: half naked, head shaved, he lies

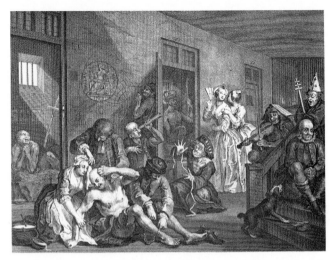

4. *A Rake's Progress* by William Hogarth (1697–1764). The eighth and last panel in a didactic series that depicts Tom Rakewell's passage from sudden wealth, via drink, dissipation, and debauchery, to madness and confinement in Bedlam. Originally painted in 1733, this engraved mass-market version was published two years later and was an enormous commercial success

in Bedlam, being manacled by a keeper and with a plaster covering the wound where he has been bled, his spurned sweetheart kneeling and weeping by his side, amidst a panoply of depraved and raving lunatics.

What swiftly gave these paintings iconic status was Hogarth's clever embrace of the improved techniques for engraving images that had emerged in the early 18th century, for these allowed him to mass produce black-and-white versions of the originals, and to present them to a middle-class audience eager to put on display a facsimile of aristocratic taste for art, and to advertise their own embrace of conventional morality. Hogarth had rendered the interior of Bethlem with remarkably fidelity (he would later become one of the hospital's governors), and other artists soon

followed his lead, making use of the dramatic possibilities of illustrating madness and the madhouse. Many pirated and simplified versions of the Rakewell image were rushed to market.

Later editions of *The Distress'd Orphan* carried engraved illustrations of Annillia being seized and carried off to the madhouse. 'Crazy Kate', or 'Crazy Jane', a servant girl seduced and abandoned by her cynical lover, had been sung about in ballads, and now appeared in a variety of portraits, always with staring, mad eyes, and often with other signs of evident distraction: straw in her hair, hands poised to scratch and assault, *en deshabillé*, with naked breasts provocatively on display. (A century on, the mad British artist Richard Dadd, confined successively in Bethlem and the new asylum for the criminally insane, Broadmoor, after he abruptly cut off his father's head, would employ a male model – all that was available to him in his confinement – and paint a particularly striking variant of the genre, an indication of the continuing cultural resonance of these tropes.)

The leading satirical artists of the late 18th century, Thomas Rowlandson and James Gilray, returned again and again to the theme of madness, Rowlandson portraying the leader of the Whig opposition, Charles James Fox, maddened by ambition and trussed up in a straitjacket, being examined through a quizzing glass by the apparently equally mad John Monro, physician to Bethlem, before being carted off to the wing for incurable lunatics; and Gilray savaging both King George and the political classes more generally (not sparing the notorious Duchess of Devonshire) as mad creatures leading the country to rack and ruin.

And so to Francisco de Goya's haunting images of the madhouse: not stylized satire, like Hogarth's famous image, but searing, raw representations of the mad (perhaps a vision that captured his fears about the prospect of his own descent into madness). One such painting was of an interior, a chaotic scene, with half-clothed and naked figures, some in shadows, others bathed in light

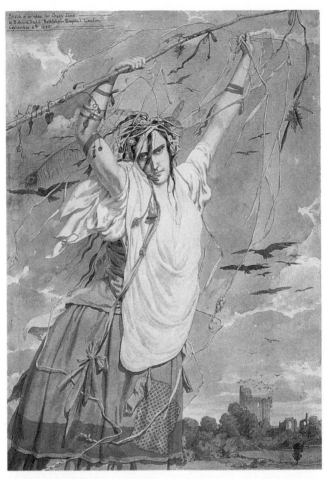

Sketch of an idea for Crazy Jane
by Richard Dadd. Bethlehem Hospital London
September 4th 1855.

5. *Crazy Jane*, by Richard Dadd (1817–86). Confined as a criminal lunatic from 1844, first in Bethlem, and then, from 1864, in the newly opened hospital for the criminally insane, Broadmoor, Dadd remained a highly productive artist, painting this striking watercolour just a year before his death

streaming through a high, barred window; another depicted an exterior, giving us a vision of naked madmen fighting amidst a collection of fellow lunatics indifferent to their fate, self-evidently too obsessed with their own wild imaginings to care about the violence being transacted in their midst. This was a nightmare world, akin to Goya's terrible and shocking images of *The Disasters of War*, with all their unforgettable mixture of sadism, cruelty, and intimations of evil.

If madness thus becomes a staple of works of the imagination in the 17th and 18th centuries, it also becomes a topic of new speculations by medical men, and others seeking to understand its mysteries. To be sure, much of the new medical literature on madness remained firmly within the ancient humoral tradition, whose flexibility and ability to integrate mind and matter, passions and bodily ailments, within a single over-arching system of

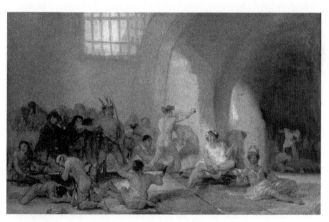

6. *The Madhouse*, by Francisco de Goya (1746–1828), painted c. 1812–14, and providing an unvarnished picture of the confinement of the insane

explanation rendered it attractive to doctors and the educated laity alike. Its assumptions about the foundations of illness and health were deeply ingrained in European culture, and once within its magic circle, any disorder, any possible outcome could be provided with a name, a rational explanation, and a course of treatment, all of which were (as they remain in our own day) a source of great comfort and consolation, independent of whether they actually conduce to a cure. To be sure, a handful of dedicated anatomists, largely practising on the bodies of executed criminals, were finally revising the mistaken models of the human frame inherited from Galen. And one of these, Thomas Willis, the Sedleian Professor of Natural Philosophy at Oxford, had joined with others in giving prominence to a newer system of regulation of the body: the brain and the nervous system.

Hippocratic and Galenic medicine saw disease as constitutional, the upsetting of the body's natural equilibrium. The ancients had looked to the balance or imbalance of the four humours – blood, black bile, yellow bile, and phlegm – to understand the systemic disturbances that produced the symptoms patients and their doctors observed. In turn, these understandings guided the physician in his choice of remedies, each aimed at getting the disease out of the body – via vomits, purges, bleedings, and measures designed to sweat noxious elements out; or by setting up sources of counter-irritation, blisters, setons, and the like, which could draw disease away from more critical areas of the human frame, and offer them a free passage out of the body in the form of pus.

The new doctrine of the nerves, put forth by men like Willis, the Swiss Albrecht von Haller, and the Scot William Cullen, was similarly systemic in its approach. Mind and body met and somehow interacted through the brain and the nervous system, whose 'animal spirits' commanded and controlled the body. Hence, in Willis's words, it was to 'the anatomy of the nerves' that one should look, 'for by means of it, are revealed the true and

genuine reasons for many of the actions and passions that take place in our body...'. Deranged nerves could be invoked to explain all manner of illness and pathology, nowhere more readily, of course, than in the case of the mad, and they could do so alongside more traditional accounts, which they supplemented rather than displaced. Taken up by new generations of doctors, Willis's and Whytt's notions of animal spirits moving speedily or slowly through the delicate network of tubes or fibres that made up the brain and nervous system soon acquired a widespread currency in lay as well as medical circles (for lay and professional conceptions of disease still overlapped very considerably, and the educated classes happily embraced these new-fangled, mechanistic ideas, which carried with them some of the prestige of the new Newtonian science).

Sufferers from milder forms of mental and emotional disturbance ('diseases' many had been inclined to dismiss, then as now, as *maladies imaginaires*) hastened to employ the new language of 'nerves', and as rapidly found society doctors all too willing to endorse such claims and to treat their disorders. Recalcitrant such disorders might be, but (partly in consequence) they were potentially enormously profitable. And behind them, of course, lurked more serious manifestations of a 'Machine out of Tune', madness and lunacy: equally the product, as the English physician Nicholas Robinson insisted, of 'Changes in the Motion of the [nervous] Fibres'.

Others, too, were drawn to the intellectual puzzle that was madness. Philosophers like John Locke, delving into the mysteries of human understanding, were also tempted to discuss its absence or distortions. Lockean philosophy prioritized experience, and pictured the mind at birth as a *tabula rasa*, a blank slate, on which experience wrote its lessons. The education of the senses was thus the key to the development of human consciousness and to the production of regular patterns of thinking. Sensations were at once the mind's servants, and the (not always secure) source of

its provisional knowledge of the world: 'methinks, the understanding is not so much unlike a closet wholly shut up from light, with only some little opening left, to let in external visible resemblances'. In misconception lurked madness, for then one is led to draw:

> a just inference from false principles…A madman fancies himself
> a prince; but upon his mistake, he acts suitable to that character;
> and while he drinks his gruel, and lies in straw, yet you shall see him
> keep the part of a distressed monarch in all his words and actions.

Some modern commentators have been tempted to see in Locke's views on the plasticity of human nature and the educability of man the source of a new, more optimistic view of madness, one that emphasized in a new way the possibility of cure, and even pointed the way towards a kinder, gentler treatment of the mad. That was certainly one possible inference from Locke's views, and in the late 18th century a perspective that began to emerge in certain quarters. Equally, however, Locke's views could license a fiercer response to the problem of how to break the preternatural hold mad ideas seemed to have over the minds of the lunatic.

The very tenacity with which maniacs adhered to their false and mistaken perceptions, heedless of the ordinary corrective processes provided by experience and persuasion, testified to the weight and strength with which they were impressed upon the brain. By implication, extreme measures might be required and justified to jolt the system back into sanity. Locke had emphasized the direct relationship between the strength of a particular sensation and the vividness of any given idea. Coupled with the notion that the cure of madness required the supersession of defective learned patterns of thoughts, such theorizing could provide the rationale for the employment of extreme forms of therapeutic terror. And this was no idle, abstract possibility. In England, in Germany, in France, in what would become modern Belgium, in the United States, the second half of the 18th and the

early 19th centuries saw experiments with strange technologies to produce such severe frights: whirling chairs that affected both body and mind, producing 'fear, terror, anger and other passions', but also rapid changes in the body, 'fatigue, exhaustion, pallor, horripilatio [hair standing on end], vertigo', vomiting, and unconsciousness; 'baths of surprise', where seemingly solid floors were designed to collapse and suddenly deposit unsuspecting lunatics in vats of cold water; elaborate contraptions that held patients under water and persuaded them they were about to drown; and the American Benjamin Rush's famous 'Tranquillizer', a chair that encased the madman's head in a padded box that excluded light and sound, and kept his arms and legs pinioned in place, while warm and cold water was applied to head and feet.

Philosophical reflections on madness could thus have very practical applications. They also played an important and long-lasting role in medical theorizing about mental disturbance, an influence scarcely confined to that of British empiricists like John Locke. Indeed, the very model of a European rationalist philosopher, René Descartes, had arguably an even more pervasive influence on medical thinking, and, over the centuries since, the medical profession's defence of its claims to jurisdiction over the management of the mad. The famous Cartesian aphorism, *cogito ergo sum* (I think, therefore I am), encapsulated a metaphysical dualism, mind and matter, body and soul, that had a long history in Western thought, but which here was advanced as the very foundation of all certain knowledge. The rational mind, identical to the immortal soul (and both *'l'âme'* in French), stood in contrast to the material, mortal body. By definition, the former was incapable of error (or could be drawn into error only by the failures of its means for perceiving the world and organizing humans' response to it, the brain and the nervous system). Madness, thus, was rooted in the body, the natural province of the physician. To argue the contrary was to imply that the mind was subject to disease, debility, or even (in the case of outright idiotism) death; in other words, to contradict the very

35

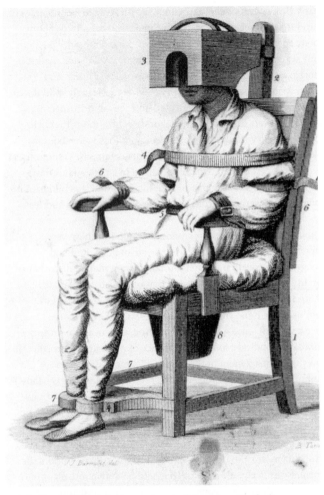

7. 'The Tranquillizer', the name given to this contraption by its
inventor, the American mad-doctor (and signatory of the Declaration of
Independence), Benjamin Rush (1746–1813). Designed to immobilize
the patient, and shut out sound and light, it purported to act
simultaneously on mind and body, and thus to calm those confined in it

foundation of revealed religion and morality, the belief in an immortal soul.

Until well into the second half of the 19th century, medical men would rehearse these arguments, which rapidly became the ruling orthodoxy in their midst. While there were a handful of medical materialists, men who simply saw mind as epiphenomenal, that was a dangerous position, one that invited lay opprobrium and even professional ruin, as a few foolhardy souls discovered. By contrast, the adoption of Descartes' dualism (whether or not one signed on to his fudge that the pineal gland was the location where the material and immaterial somehow blended), provided a wholly satisfactory account of madness's origins, one that placed it firmly within the medical profession's acknowledged sphere of expertise, and provided a powerful social warrant for its jurisdictional claims. 'From the admission of this principle', as the Scottish psychiatrist W. A. F. Browne put it, 'derangement is no longer considered a disease of the understanding, but of the centre of the nervous system, upon the unimpaired condition of which the exercise of the understanding depends. The brain is at fault, and not the mind.' 'In all cases where disorder of the mind is detectable', he continued, 'from the faintest peculiarity to the widest deviation from health, it must and can only be traced directly or indirectly to the brain.'

These medical accounts of madness did not go unchallenged. On the contrary, older religious and even satanic explanations of mental troubles continued to have their advocates. Indeed, in England they were energetically put forward by evangelical Christians, most especially by the founders of Methodism, Wesley and Whitefield. Like other enthusiastic Protestants, they invested mental turmoil with profound spiritual significance. Anxiety and despair, the tortures provoked by the acknowledgement of guilt and sin, the perils of damnation and the promise of salvation, the literal struggle between the Divine and the temptations of the Evil One for the possession of an individual's soul: these were central

37

elements of new religious movements that steadily gained adherents in the 18th century. In such circles, scriptural discussions of demons and witches served to reinforce popular belief in an almost palpable spiritual world of supernatural malevolence, one of whose most visible manifestations were maladies of the mind. Religious revivalists thus helped to secure the survival of earlier perspectives on madness that mixed together religious and magical causation with naturalistic forms of explanation, and saw divine retribution, demoniacal possession, witchcraft, or the misalignment of one's astrological signs as being as (or more) plausible an explanation of distraction as an account pitched in terms of bodily indisposition. Logically enough, Wesley and his followers developed alternative forms of religious and spiritual healing – vigils, fasting, and prayers – as a response to mental tribulations. To which the riposte of many doctors was that enthusiastic religion was itself a form of madness, or even, through its incitement of the fear of damnation, a potent cause of the disorder in those exposed to its doctrines.

The wildest, most threatening of madmen had always been liable to be locked up in some fashion – whether the improvised means of restraint adopted by desperate families, or the expedients used by the community: gaols, guard towers, and the like. In France, the royal authorities, fearful that the poor and the vagrant might be a threat to their power, sought, from the mid-17th century onwards, to confine the idle and the dissolute on a broader scale. *Hôpitaux généraux*, the first of which was established by royal decree in Paris in 1656, soon absorbed a sizeable fraction of these marginal populations, some of whom undoubtedly were mad. Beginning in 1764, when the *hôpitaux généraux* proved unable to contain all the beggars and whores, a parallel set of institutions, the *dépôts de mendacité*, were created, and these too took in numbers of lunatics whose families refused to care for them. In the principalities across the Rhine, later and in a much more haphazard fashion (which reflected the political fragmentation and heterogeneity of the German-speaking world), a variety of old

buildings were recruited to confine a fraction of the dissolute and the idle. Again, some of the mad found themselves in these netherworlds, for lack of any alternative. But in neither case was there any attempt at a mass sequestration of the insane.

The late French philosopher-cum-historian Michel Foucault used the pages of his book *Madness and Civilization* to invent the notion of a Great Confinement of unreason during what he called 'the classical age'. He pictured the emergence of 'a social sensibility...that suddenly began to manifest itself in the second half of the seventeenth century...[one] that suddenly isolated the category destined to populate the places of confinement'. The upshot, he asserted, was a symbolic and literal caging of the mad, what he characterized as a revolutionary break with the past that saw the lunatics cast out from the community they had once moved freely amongst. Foucault's was a seductive image, one that helped to make him famous and to attract legions of disciples. But for all that, it remains a late 20th-century ideological construct, one with little or no contemporary relevance or resonance in the societies it purports to describe.

There were, nevertheless, changes afoot in the handling of small numbers of the mad in this period, and they were changes that, in hindsight, would prove enormously consequential. At first, these emerged from a series of informal and pragmatic arrangements some families began to make with outsiders, to rid themselves of the social embarrassment, the never-ending emotional upset, the massive disruptions, and the physical threats that the presence of a mad relative in their midst inevitably brought in its train. Rather than attempting to care for the lunatic at home, arrangements might be made to board them elsewhere, where they might perhaps be less subject to neighbourhood gossip, and less able to create disruption and trouble. Entrepreneurs soon emerged willing to provide such services in a quasi-domestic setting, offering secrecy, as well as respite from near-overwhelming emotional and physical burdens. In France, these establishments

became known as *petites maisons*, and in England, as 'madhouses'.

In Georgian England, like much else in what was an extraordinarily innovative social order, the arrangements that emerged for handling the insane were *ad hoc* and unsystematic. Those entering the mad-business were drawn from a wide range of backgrounds – clergymen, both orthodox and non-conformist, businessmen, widows, surgeons, speculators, and physicians – any and all were free to enter the trade. In the absence of any official regulation or oversight, an open marketplace produced a predictably heterogeneous set of arrangements, with institutions varying widely in size, clientele, organization, and therapeutic regime. Here was a social space that allowed for considerable experimentation, and in the process contributed to the development of craft-based skills in the management of the mad. But here, too, was a school for scandal. The very nature of the mad-business, with its attendant secrecy and physical isolation, almost inevitably created gothic fantasies about what transpired behind asylum walls. And with an inverse relationship between the size of a madhouse keeper's profits and the amount of money spent on his inmates, there were structural incentives for mistreatment.

What in England was dubbed 'the trade in lunacy' almost immediately attained a cultural notoriety out of all proportion to the actual size of the industry. (Even by the end of the 18th century, no more than two or three thousand souls were confined in English madhouses, and probably no more than thirty to fifty practitioners were specializing in the treatment of the mentally disturbed.) The majority catered to the rich, for that was where the money was, but parishes were also beginning to get in on the act, paying small sums to those willing to provide places of confinement for difficult or impossible characters of a meaner sort – and in London, some of these establishments grew to a remarkable size, contained two, three, even four hundred at a

time. But it is easy to overestimate the contemporary significance of these mansions of misery.

Although in theory madhouses might provide an invaluable mechanism for drawing a discreet veil over the mad relative's very existence, rich families often recoiled from taking advantage of such sinister silences. At the other end of the social spectrum, public authorities were understandably reluctant to spend money incarcerating poor lunatics, save where the sheer extravagance of the mad person's behaviour, and the perceived threat they posed to the surrounding community, prompted a more interventionist stance. (Likewise in France: the Hôtel-Dieu was by the surgeon Tenon's account the only public provision in Paris in the late 18th century for such of the mad who might prove curable, and its two wards for the insane, tucked away in a huge ramshackle institution mostly devoted to the flotsam and jetsam of the capital, contained a grand total of 42 men and 34 women.) Demonstrably, most people preferred to seek other solutions to the problems their mad relations posed, and, if affluent, they possessed the means to do so. And yet the image of the madhouse acquired an ever greater hold over the public imagination.

In the protest pamphlets of a Daniel Defoe or an Alexander Cruden, the threats such places represented to the rights of the free-born Englishman (or woman) were prominently advertised. In the prose of the high-class novelist – Richardson, Smollett, MacKenzie – madhouse scenes and ruffianly characters served to titillate and entertain readers from the respectable classes. And for a larger mass market, the sinister and corrupt possibilities of these miniature worlds were employed to still more melodramatic effect, in tales of 'Pityless Monsters' who 'delighted in inflicting Pain'; of females confined in 'Chains and Nakedness'; or of sane persons locked up and abused, till they were driven mad by the torments of their keepers, and the spectacle of their fellow inmates. So far as its public image was concerned, the madhouse was the Hades where increasing numbers of dead souls gathered

to wallow in their miseries, and to be taunted and teased by those who proclaimed themselves their protectors.

As for those who presided over these establishments, many of the mad-doctors, as they came to be called, gained fortunes from meeting the demands and desires of their patients' families. (Anthony Addington's madhouse at Reading, for example, provided the foundation of the family fortune and his ascent to the rank of court physician, not to mention helping to underwrite his son's rise to be prime minister of Britain.) But in return, they were the butt of satirical commentary, their social standing diminished by their participation in a speculative trade, their motives and competence routinely questioned and lampooned in pamphlets and the popular press. The commerce the mad doctor made out of madness left an indelible stain on his social pretensions. It was a lack of legitimacy that would cling to psychiatry ever after.

Chapter 3
Madness confined

Eighteenth-century Bethlem had promiscuously invited outsiders inside its walls. Till 1770, anyone could visit the wards of the ancient foundation. The inmates were mostly unwilling actors in a theatre where the throngs of visitors might inspect the product (and price) of immorality, and the wreck of the human intellect. Public visiting was finally curtailed in 1770, a shutting off as well as a shutting up of the patients that ironically would end up exposing them in time to yet greater abuse. Throughout the 18th century, therapeutics at Bethlem were characterized by relatively uniform purges, bleedings, and vomits, administered seasonally to patients, with the occasional addition of tonics (such as alcohol) and cold bathing, with these heroic interventions being supplemented by a mostly lowering form of diet and regimen. This model of treatment, whereby repletion in the system was countered by depletion and vice versa, was founded on an essentially humoral approach to mental diseases. Overlaid since the late 17th century by a new mechanistic brand of 'Newtonian' medical science, older principles and even types of treatment had in reality changed remarkably little.

Such therapeutic conservatism was by no means universal, however. As the number of institutions devoted to the confinement of the mad began to grow over the course of the 18th century, so too did opportunities for experimenting with differing

approaches to their management. To be sure, in most hands this meant the employment of techniques that emphasized the use of fear, awe, and dread. Chains and other forms of mechanical restraint continued to figure prominently in this regime of coercion, being seen as useful, even essential, adjuncts in the effort to compel right thinking. But elsewhere, very different tactics began to be employed. In Florence, in Paris, in Manchester, Bristol, and York, seemingly independently of each other, those in charge of institutions for the mad began to develop techniques that insisted on minimizing external, physical coercion, which might force outward conformity, but which could never produce what was now seen as the essential internalization of moral standards.

Within what rapidly became the new orthodoxy at the turn of the 19th century, attempts to compel patients to think and act rationally would themselves be stigmatized as irrational. The very effort to tame madness was seen as seriously misguided, and formerly respectable therapeutic techniques were discarded, coming to be seen with a mixture of incomprehension and moral outrage. What was most remarkable about the new approaches, however, particularly in light of the negative image that the madhouse had already acquired and that the new lunatic asylums would subsequently inherit, was how extraordinarily optimistic their proponents were about the efficacy of their chosen remedies, and how tightly their techniques were bound up with the confinement of the insane in what was pronounced to be a therapeutic isolation.

The most famous architects of the new approach, the physician Philippe Pinel in post-revolutionary Paris and the tea and coffee merchant and Quaker William Tuke in York, both termed this new approach 'moral treatment'. Pinel had learned the new techniques primarily from the layman Jean-Baptiste Pussin who ran the wards for the incurably insane at the Bicêtre, the male section of Paris's Hôpital Général, and not long after, Pinel also took charge

of the insane wards at its female counterpart, the Salpêtrière. The myth of him striking the chains from the hands and feet of these inmates at the height of the post-revolutionary Terror is pure fiction, manufactured decades after the fact, but it precisely captures one of the central appeals of moral treatment, its sharp rejection of what was now seen as the harshness and cruelty of the past, including its unequivocal rejection of iron fetters and corporal punishment (though by no means of all forms of restraint). Pinel shared with Tuke the notions that the mad could be induced to collaborate in their own recapture by the forces of reason; that most medical remedies for madness were useless; and that the supposedly continuous danger and frenzy to be anticipated from maniacs were the consequence of, rather than the justification for, misguided methods of management and restraint.

As one contemporary madhouse keeper, Thomas Bakewell, put it:

> Certainly authority and order must be maintained, but these are better maintained by kindness, condescension, and indulgent attention, than by any severities whatsoever. Lunatics are not devoid of understanding, nor should they be treated as if they were; on the contrary, they should be treated as rational beings.

All aspects of the mad person's environment should be employed to rouse the moral feelings, and to induce the patient to control him- or herself. Making use of the vital weapon of people's 'desire for esteem', their need to look well in the eyes of others, the mentally disturbed could be induced to collaborate in their own recapture by the forces of reason. Under the direction of a benevolent paterfamilias, and within the confines of a therapeutic environment, inmates could be encouraged and induced, in the words of William Tuke's grandson Samuel, 'to struggle to overcome their morbid propensities... [and to confine] their deviations within such bounds, as do not make them obnoxious to the family'. What was essential, Pinel

concurred, was 'great firmness, but not harsh and forbidding manners; rational and affectionate condescension, but not a soft complaisance that bends to all whims'. Treated in this fashion, madness could thus be reined in amid the confines of domesticity by the invisible, yet infinitely potent fetters of the sufferer's own desire to please others, assisted by the efforts of the asylum's guiding influence, its superintendent, and by the careful employment of space itself to reinforce moral boundaries and behaviours.

In Britain, in France, in some of the German principalities, and in the new American republic, the dawn of the 19th century thus witnessed the birth of an extraordinary optimism about the therapeutic possibilities of an asylum reorganized in accordance with these principles. Those promoting the new realm of asylumdom basked in the assurance that their creation marked a clear rupture with the coercion, fear, and constraint of an earlier madhouse regime, the replacement of a 'moral lazar house' with the 'moral machinery' through which the mind would be strengthened and reason restored. Reformed asylums were, one mid-century English enthusiast proclaimed, 'the most blessed manifestation of true civilization the world can present'. The principles of a rational, a humane, and above all a curative treatment of the insane were at last at hand.

Nowhere was this utopianism more evident than in the United States, where a veritable 'cult of curability' arose in the 1820s and 1830s, with claims to cure 70%, 80%, 90% of recent cases of insanity becoming routine. Dorothea Dix, the moral entrepreneur most responsible for America's embrace of the asylum, constantly informed the politicians she lobbied that 'all experience shows that insanity reasonably treated is as curable as a cold or a fever'. But everywhere, reformers embraced the notion that adoption of their nostrums was the key to eliminating the scourge of insanity. There existed, they insisted, an economics of compassion, for to treat the mad in an institution run on moral treatment lines was

to rescue fellow creatures from mental tortures, and to return them to the ranks of productive citizens.

Contrasting such idylls to the horrors faced by the insane in prisons, in workhouses, even at the hands of well-meaning but ignorant relatives, and forcefully distancing their schemes from the horrors of the *ancien régime* madhouse, enthusiasts for the programme of placing the mad into therapeutic isolation fought successfully to transform public policy, and to create whole networks of specialized institutions, the majority built at public expense for the poor and middling sorts, though attempts were also made to entice the rich to see the advantages of private asylums catering to their mad relations. A century earlier, the corpulent diet doctor George Cheyne had augmented his professional fortunes by proclaiming that milder forms of mental disease – nervous disorders like hysteria, hypochondria, and the spleen were the peculiar province of the hyper-civilized and hyper-refined, those with the most delicate of nerves stretched to breaking point by the pressures and temptations of modern civilized living. In the 1830s and 1840s, such ideas were expanded to encompass the more serious forms of madness.

On the one hand, the Rousseauist myth that the Noble Savage was largely immune to the ravages of insanity was widely canvassed. On the other, the dangers of civilization were made manifest: 'With civilization', warned the Scottish alienist W. A. F. Browne, 'come sudden and agitating changes and vicissitudes of fortune; vicious effeminacy of manners; complicated transactions; misdirected views of the objects of life; ambition, and hopes, and fears, which man in his primitive state does not and cannot know.' His famous French contemporary, Jean-Étienne Esquirol, agreed: madness was more common among the rich than the poor, a greater risk to the bourgeoisie and the plutocracy than to the peasant or the worker. Exposed to fewer temptations and less stress than their social betters, the humble and the illiterate were relatively immune to the ravages of mental disorder. All the more reason, of course,

for the wealthy to support the construction of asylums run on moral treatment lines, lest they find themselves locked up in the living tomb that was the traditional madhouse.

All across Western Europe and North America, a veritable mania for the construction of the new institutions for the insane marked the middle decades of the 19th century. In the process, what was proclaimed to be lunacy reform gave birth, not just to a vast new network of asylums, but also helped to create the conditions for a new and increasingly self-conscious group of 'experts' in the diagnosis and treatment of madness. It was a fraught process at first, for in England in particular, much of the moral energy and outrage that fuelled the drive for reform had arisen from graphic exposures of the abuses that had taken place in more traditional institutions, many of them medically run. At Bethlem, for instance, those converted to the merits of Tuke's moral treatment had discovered a multitude of scandals: patients chained naked to the wall, suffering from frostbite and loss of their extremities; female patients raped and impregnated by their keepers; a routine of vomits and bleedings; cells redolent of shit, straw, and stench; and, most famously of all, a certain James Norris, an American seaman found confined in a sort of iron cage which encased him from the neck down and was attached by a short chain to an iron bar running from floor to ceiling – an apparatus in which he had been kept for a decade and more, though it left him unable to move more than a foot in any direction. Discoveries like these threatened to call into question the legitimacy of medicine's authority over madness, the more so since moral treatment was in many ways a lay invention, whose proponents had declared that traditional medical therapeutics were largely useless when mobilized against the ravages of mental illness.

But by making their peace with moral treatment and adopting its tenets, while re-emphasizing that madness was rooted in the body, medical men saw off the challenge. Once more, many of them relied on the notion that had been advanced a century

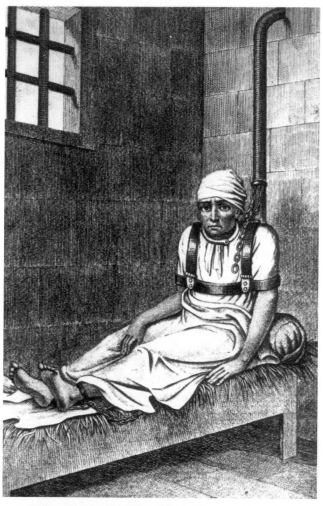

8. James Norris, often mistakenly called William Norris, an American seaman confined in this fashion in Bedlam for more than a decade. This image, drawn from the life, was mass produced and used to great effect by early 19th-century lunacy reformers in England

earlier, that to proclaim the mind itself was diseased was to call into question the integrity and immortality of the soul, and thus to undermine both revealed religion and social order. They asserted that a judicious combination of moral and medical remedies was superior to a misplaced reliance on one or another, and produced statistics that 'proved' the point. And they sought, though without significant success, to uncover differences in the anatomy of mad brains. By mid-century, across a wide variety of national settings, the previously heterogeneous congeries of madhouse keepers had instead become a more and more organized group of specialists. Journals dedicated to the discussion of madness and its treatment had begun to appear in English, French, and German, providing a regular medium of exchange for the emerging profession and a public warrant for its claims to possess a burgeoning expertise in the management of the mad. The simultaneous creation of professional associations of asylum doctors both exemplified and confirmed the trend.

Henceforth, madness and the branch of medicine devoted to its treatment would be inextricably intertwined. The identification and treatment of madness, the explanation of its aetiology, the very language used to discuss it, all were increasingly the products of the new psychological medicine, and the institutions its practitioners presided over served to isolate the lunatic in a new carceral archipelago. No longer answering to the title of 'mad-doctor', whose ambiguity and associations with the *ancien régime* madhouse they disdained, there was as yet no broad consensus among them on what new name to adopt. The French preferred *aliéniste*, the Germans *Psychiater*, while their Anglo-American counterparts at first declined both labels, opting for 'medical psychologist' or asylum superintendent. The latter was an awkward term that at least captured how tightly their identity was bound up with the institutions they headed, asylums that confined them almost as totally as the patients to whom they ministered. The international hegemony of 'psychiatry' as the preferred term of art would not be established till the dawn of

the 20th century, so its use in the remainder of this chapter will be to some degree an historical anachronism. Its decisive merit, though, is that it avoids a whole series of clumsy circumlocutions, so I shall embrace it anyway.

All too soon, of course, the utopian dreams of the reformed asylum's advocates collided with the recalcitrant reality that mental disorders would not yield so readily to the blandishments of the moral treatment regime. Though the invention of a more benevolent image for the madhouse was a vital piece of ideological work for those who sought to construct publicly funded asylums, the social space that now contained madness could not long sustain the illusions its promoters had so sedulously constructed and promoted. Ironically, what was intended as a grand gesture of reform, a release of the mad from their chains, thus led inexorably to their mass confinement in a vast network of museums of madness. Here the insane were shut up in multiple senses of that term, isolated from the larger society, objects first of pity, then of fear and disdain.

Asylums seemed to serve as magnets, drawing forth an endless stream of mad folk from the surrounding community. Most of them seemed to come from the ranks of the poor and the middling sort, and it was the institutions set up at public expense that grew most rapidly. In part, this apparent social location of madness was an illusion. Victorian letters, diaries, and autobiographies provide ample evidence that, despite all the propaganda in favour of reformed asylums, upper- and middle-class families feared them, and had low expectations about the kind of care their relatives would receive in confinement. And certainly only a handful of private asylums – places like Brislington House and Ticehurst in England, the McLean Asylum and the Hartford Retreat in the United States – could offer a regime even remotely approaching the upper-class mode of life. Necessarily, institutionalization thus constituted a degrading experience for those exposed to it. Wealth and social standing allowed certain families to circumvent or

postpone the disgrace of incarcerating one of their nearest and dearest in the asylum. Upper- and upper-middle-class families possessed the financial wherewithal to cope with the unproductive and disturbed; the ability to employ large numbers of servants to manage their troublesome relatives; the capacity, if need be, to send them off to a quiet and secluded part of the country, or even abroad; and strong motivation to avoid the scandal and stigma that were still the consequence of having a relative officially certified as mad. Once family tolerance and resources had reached breaking point, though, ties of blood tended to accentuate rather than diminish the desire for seclusion in an asylum.

Among the rich, though, the reformed asylums still roused some of the fears that had first surfaced with the creation of the madhouses more than a century earlier. The very seclusion and secrecy that, on the one hand, was a source of the institution's appeal, on the other hand aroused anxiety, for these attributes might be exploited by those with corrupt motives to incarcerate the sane among the lunatic, to be rid of an inconvenient relation, for instance, or to seize control of another's property. Lawsuits alleging such activities surfaced from time to time on both sides of the Atlantic. America had its Elizabeth Packard, a clergyman's wife whose husband had her confined as mad, only for her to launch a one-woman crusade across several states, impugning the competence and the honesty of the doctors who had confined her, and seeking jury trials for all those threatened with incarceration in a lunatic asylum. England had its equivalents: the titillating and high-profile suit brought by Lady Rosina, the estranged wife of the popular novelist Sir Edward Bulwer Lytton, who had been so ill-advised as to confine her in a madhouse; and the serial complaints of another former patient, Louisa Lowe, who labelled private asylums English Bastilles and spent years agitating against their very existence.

It is perhaps more than coincidental that the majority of these complaints seem to have involved women (though they certainly

had their male counterparts). Feminist critics and historians have been inclined in recent decades to see in these agitations the development of some sort of proto-feminist consciousness, a battle by some brave members of their sex against the inclination of Victorian alienists to use their 'science' to reinforce male prejudices about woman's place. (That prominent psychiatrists and neurologists like Henry Maudsley and Jean-Martin Charcot, to say nothing of a host of lesser figures, acted in precisely this way is incontrovertible.) Certainly, such well-publicized legal affrays heightened anxieties about both psychiatry and its institutions, and these doubts and fears were exploited and reinforced in still another arena: the realm of fiction.

To be sure, the most famous early Victorian novel to employ madness as a central element in its plot, Charlotte Brontë's *Jane Eyre*, left the asylum and the mad-doctor out of the picture entirely. Mad Bertha Mason, hidden in Mr Rochester's attic, embodies ancient stereotypes about madness and animality. Jane is 'introduced' to Mr Rochester's sequestered wife:

> In the deep shade, at the further end of the room, a figure ran backwards and forwards. What it was, whether beast or human being, one could not, at first sight tell: it grovelled, seemingly, on all fours; it snatched and growled like some strange wild animal: but it was covered with clothing, and a quantity of dark, grizzled hair, wild as a mane, hid its head and face.

Shrieking, violent, dangerous, and destructive, fit only for confinement apart from society, here is the mad-woman as fiend, not victim. But *Jane Eyre* appears in 1847, just as the asylum is about to become the orthodox response to madness, and the novel's mad character is subject to domestic confinement, not carted off to a specialized institution. By contrast, Wilkie Collins' *The Woman in White*, and Charles Reade's (at the time equally celebrated) novel *Hard Cash*, which were published in 1860 and 1863 respectively, make illegitimate confinement of sane

characters in asylums crucial features in their melodramatic plots. And Reade, in particular, delights in portraying psychiatrists as bumbling and/or corrupt, experts in studying 'pounds, shillings, and verbiage', and in not much else. Both books enjoyed runaway success in the marketplace, and both did nothing to enhance the asylum's image in the eyes of their affluent readership.

It is much harder to know how the poor and unlettered felt about asylums, for they left, of course, few or no written records of their own. Certainly, their straightened social circumstances, the narrow margin many of them experienced between subsistence and starvation, and the crowded character of their living arrangements must have heightened the difficulties they experienced in coping with the disruptions and depredations of the mad. Yet the asylum's associations with the hated Poor Law and its stigma – England's county asylums, for example, which confined more than 90% of its institutionalized mentally ill, were administered throughout the 19th century as part of the Benthamite Poor Law, and their inmates were officially referred to as 'pauper lunatics – not to mention its reputation as, in the words of one contemporary, 'the Bluebeard's cupboard of the neighbourhood', must have acted as a deterrent to the use of its services. Desperation often won out. The old, the violent, the deluded, those poisoned by over-consumption of alcohol or contact with heavy metals, mothers suffering from post-partum depression, and the myriad victims of what we now know was tertiary syphilis, diagnosed at the time as general paralysis of the insane (a reflection of its deadly mix of neurological and psychiatric deficits) – many of these and other kinds of threatening, troublesome, and impossible people found their way into the asylum. They constituted the heterogeneous population that made up the mad, and were the burden psychiatrists and asylum attendants perforce had to care for and cope with, and to try to comprehend. (The complications of tertiary syphilis alone accounted for 10–15% of admissions – rising as high as 29.2% at the Charenton Asylum in Paris in the last quarter of the 19th

century – and alcoholic poisoning and delirium tremens were responsible for about as many.)

The consequence is clear: asylums swiftly began to silt up with what the Scottish psychiatrist W. A. F. Browne called 'the waifs and strays, the weak and wayward of our race'. It would be wrong to think that admission to an asylum was necessarily a one-way ticket to oblivion. The manias of the alcoholic, the depression of new mothers, the despair and debilitated state of some of the poorer sort who found their way into a mental institution, the melancholy of those overwhelmed by the trials of their fraught existence – all of these forms of mental distress at times remitted with care and time in the asylum. In other instances, even in the absence of cure, the temporary respite institutionalization provided from the burdens of the lunatic seems to have sufficed to encourage families once more to resume the attempt to cope with their presence at home. At the margin, therefore, Victorian asylums continued to discharge perhaps one-third or two-fifths of each year's intake within 12 months, and an annual mortality rate of 10–15% of those resident further reduced numbers. But the obverse of this situation was that every year, a substantial fraction of each year's intake remained behind, swelling the ranks of the chronic, 'incurable' patients, and contributing to the remorseless upward pressure on asylum accommodation. Simple mathematics ensured that annual admissions constituted a smaller and smaller fraction of those under 'treatment', and that the median length of stay in the asylum grew ever longer. It was this horde of the hopeless, and the associated spectre of chronicity, that came to haunt late 19th-century psychiatry, and to influence the larger culture's view of the nature of madness.

Asylums that housed a hundred or two inmates at mid-century had grown to a thousand and more by century's end. Mental hospitals (as they were relabelled late in the 19th century) grew into miniature (and soon not-so-miniature) towns, with their

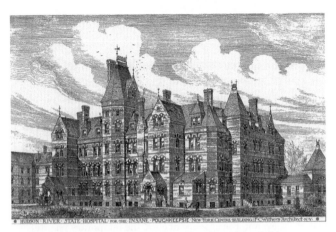

9. The central building at the Hudson River State Hospital in Poughkeepsie, New York, completed in 1871, one of the many museums of madness to be found all across North America and Europe by the late 19th century

own gas works, water supply, chapel, mortuary, and graveyard, sometimes their own police force and fire brigade. The London magistrates, for example, built a series of establishments for a total of up to 12,000 patients on a single site at Epsom. At Milledgeville in Georgia, the Central Lunatic Asylum eventually confined almost 14,000 patients, and a whole series of asylums on New York's Long Island – Central Islip, King's Park, and (later in the 20th century) Pilgrim State Hospital – together provided for more than 30,000 inmates. Asylums with patient censuses in the thousands likewise became common in France, Germany, and elsewhere in Europe. The huge hospital at Bielefeld, for instance, founded in 1867, grew to contain upwards of 5,000 inmates.

As early as 1868, the alienist B. A. Morel was complaining that all across France, public asylums were in a state of 'chaos, in which all the forms of intellectual degradation accumulate pell-mell,

without profit to the sick or the doctors whose entire time is absorbed by writing monthly reports…'. One of his British counterparts spoke of 'the intrinsic repulsiveness of the records of sorrow and suffering' that he confronted on a daily basis, and lamented that 'after the best application of the most sagacious and ingenious measures, the results are so barren and incommensurate, that in defiance of sympathy and solicitude, misery and violence, and vindictiveness should predominate'. And the American neurologist Silas Weir Mitchell chided America's assembled psychiatrists, complaining that they presided over an assemblage of 'living corpses', pathetic patients 'who have lost even the memory of hope, [and] sit in rows, too dull to know despair, watched by attendants: silent, grewsome [sic] machines which eat and sleep, sleep and eat'.

Madness appeared to multiply, and simultaneously to become more malignant. In Germany, the ratio of lunatics confined in asylums grew from 1 in 5,300 in 1852 to 1 in 500 in 1911. In England, over a 50-year period, 1859 to 1909, the rate of confinement more than doubled, from 1.6 to 3.7 per thousand of the general population. The promise of the reformed asylum had vanished.

It might be expected that this situation would have created profound crises of legitimacy both for the institutions and for the professionals running them who proclaimed themselves experts in the diagnosis and treatment of madness. And to some degree, this happened. Shorn of most of their curative pretensions, asylums had a difficult time justifying their expense, and a cheese-paring economy soon settled over such establishments. Yet confinement provided its own rationale, for why else were the mad locked up, unless it was unsafe for them to be at large? Mad-doctoring, now increasingly embracing the German term 'psychiatry' as German medicine moved to the forefront of scientific medicine, remained for the most part a marginal, hobbled, stigmatized enterprise. The physicians' presence provided a useful service, both to patients'

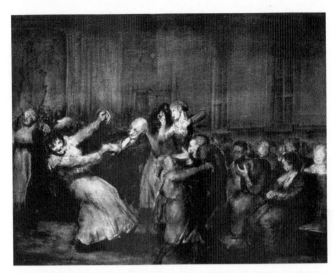

10. *Dance in a Madhouse*, by the American realist artist George Bellows (1882–1925). Dances were one of the few occasions when the otherwise rigidly segregated sexes were permitted to mingle while confined in the asylum. Attendance was a privilege that could be withdrawn instantly for 'bad behaviour', and the lunatic ball thus functioned as an occasion for displaying the asylum's disciplinary power over its inmates, and its ability to control the unruly forces of sex and madness

families, and to the community at large, as well as a medical gloss for the empire of asylumdom.

Besides, intellectuals are skilled at rationalization, at inventing accounts that justify their existence and explain (or explain away) inconvenient facts. And so it proved with madness. First in France, then in the German-speaking world, in Britain, and in the United States, the psychiatric profession began to converge around a new account of madness: one that simultaneously provided a powerful new rationale for segregating the insane; and demonstrated that psychiatry's apparent therapeutic failings were in reality a blessing in disguise.

As early as 1857, the French alienist B. A. Morel had begun to advance the new concept of 'degeneration'. 'The degenerate human being', he wrote,

> if he is abandoned to himself, falls into a progressive degeneration. He becomes...not only incapable of forming part of the chain of transmission of progress in human society, he is the greatest obstacle to this progress through his contact with the healthy portion of the population.

Soon, this concept of a biologically rooted 'social menace' spread all across Europe and North America. It surfaced in literature, most notably in the 'naturalistic' fiction of Émile Zola, where it is portrayed as threatening to trap a decadent society in its deadly embrace – an obsessive theme of the Rougon-Macquart novels. It surfaced in a very different way in Ibsen's *Ghosts*, with its graphic themes of drunkenness, incest, congenital syphilis, and madness that shocked and revolted most of its hypocritical bourgeois audience. An inherited morbid constitutional defect, worsening as defective germ plasm was transmitted across generations, came to be viewed as the biological principle underlying all the protean forms of departure from conventional morality: alcoholism, criminality, madness, idiocy, sterility, and death. Such notions were presented as 'science' for a mass audience in books such as Max Nordau's *Entartung* (*Degeneration*) (1892), with its sustained assault on 'degenerate' art and artists. Figures like Baudelaire, de Maupassant, and Nietzsche, all of whom descended into syphilitic madness, stood as exemplars of the phenomenon. So, too, did *'le fou roux'*, the red-headed madman Vincent van Gogh, whose alcoholism, epilepsy, recurrent venereal infections, self-mutilation, serial involvement with prostitutes and brothels, madness, confinement in an asylum, and eventual suicide might well have made him the poster-child for Nordau's fulminations (or alternatively, in other times and amongst those with other prejudices, for the persistent romantic notion that madness and creativity are somehow closely allied). In the over-heated culture of the *fin-de-siècle*, ideas of

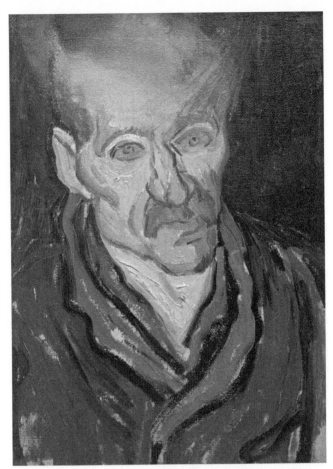

11. *Portrait of a patient at the St Paul Hospital, St Rémy*, the private madhouse to which Vincent van Gogh (1853–90) had committed himself in May of 1889, and where he would stay for most of the last year of his life

decadence, degeneration, and biological decay rapidly made their way into the vocabulary of politicians, into conversations about national decline, and hence on to the statute book.

The mad, it transpired, were 'monstrosities', 'tainted creatures', whose inherited defects and biological inferiority were written on their physiognomy. On admission to the asylum, said Daniel Hack Tuke, the great grandson of the founder of the York Retreat and the English version of moral treatment, '"No good" is plainly inscribed on their foreheads'. Men contemplating marriage were warned to be on the lookout for those 'physical signs…which betray degeneracy of stock…any malformations of the head, face, mouth, teeth, and ears. Outward deformities are the visible signs of inward and invisible faults which will have their influence in breeding.' More firmly than ever before, psychiatrists insisted that madness was rooted in the body, and they noted that its hereditary nature made it ineradicable. Worse still, legions of the hopelessly biologically defective, shorn of the restraints provided by the veneer of civilization, were liable to reproduce like rabbits, and thus threatened to overwhelm a society that mistakenly kept them alive. Hence, remarked one psychiatrist (and he spoke for many of his colleagues), 'every so-called "cure" in one generation will be liable to increase the tale of lunacy in the next'. These were sentiments that simultaneously reinforced and drew sustenance from the Social Darwinist ideas that circulated widely in late 19th-century culture.

If at one time psychiatry had advanced the claim that the pressures of civilization bore most heavily on the mental stability of those drawn from the ranks of the privileged and the professional classes, now the connections of madness and civilization were turned upside down. 'There is most madness', intoned the misanthropic Henry Maudsley, the leading psychiatrist of the late Victorian English-speaking world, 'where there are the fewest ideas, the simplest ideas, and the coarsest desires and ways'. Hence its social demography. 'Insanity does not occur', said the Edwardian psychiatrist Charles Mercier,

in people who are of sound mental constitution. It does not, like smallpox and malaria, attack indifferently the weak and the strong. It occurs chiefly in those whose mental constitution is originally defective, and whose defect is manifested in a lack of the power of self-control and of forgoing immediate indulgence.

Such people were, not to put too fine a point on it, vermin, 'moral refuse', parasites whose pedigrees, in the memorable phrase of another British alienist, 'would condemn puppies to [drowning in] the horse-pond'.

Fear of the 'feeble-minded', and of the onslaught of the mentally unfit, fed into the rise of eugenics, the 'science' of good breeding. Experts sought to encourage the well-born to breed, and to throw up obstacles to the reproduction of the unfit. Where advice did not suffice, isolation in an asylum, or even forced sterilization, were contemplated. Many American states took psychiatrists' advice and passed marriage laws forbidding the tainted to marry. But such laws proved clumsy and hard to enforce. So some states subsequently opted for compulsory sterilization of the mentally unfit. Such moves were not uncontroversial – in England, efforts to secure legislation along these lines were derailed by opposition, largely from religious sources. Faced with a test case on the question, however, and convinced by the weight of scientific opinion, Oliver Wendell Holmes wrote for a nearly unanimous United States Supreme Court that:

> It is better for all the world if instead of waiting to execute degenerate offspring for crime, or to let them starve for their imbecility, society can prevent those who are manifestly unfit from continuing their kind. The principle that sustains compulsory vaccination is broad enough to cover cutting the Fallopian tubes. Three generations of idiots are enough.
>
> (*Buck* v. *Bell*, 247 US 200, 1927)

The state, the Court held, had a compelling interest in interdicting the reproduction of the mad and otherwise mentally defective, and in the aftermath of its decision, other states rushed to embrace this approach, 40 of the 48 having compulsory sterilization laws on their books by 1940.

These were half-measures, though. The harsh language that *fin-de-siècle* psychiatry employed to refer to the mad, and the pessimism and despair that marked psychiatric theorizing about mental illness, pointed towards a darker set of conclusions. If madness was incurable and a threat to the future of the race, why should such defectives be kept alive, at great expense and some risk? Why not exterminate the problem, and those who constituted it? Such dark thoughts were only briefly and none-too-firmly broached in much of Europe and North America. Best-selling books such as Madison Grant's *The Passing of the Great Race*, largely devoted to rants against immigrants of inferior racial stock, spoke contemptuously of old shibboleths like 'the sanctity of human life', and insisted that 'The laws of nature require the obliteration of the unfit.' Charles Davenport, another leading American proselytizer for eugenics, wistfully acknowledged that 'it seems to be against the mores to burn any considerable part of our population', a reluctance he clearly found deeply regrettable. And the English psychiatrist Samuel Strahan railed against misguided attempts to cure the mad and to restore them to society, for they served only to 'prevent, so far as is possible, the operation of those laws which weed out and exterminate the diseased and otherwise unfit in every grade of life'. But these men and their allies ultimately baulked at implementing the policies to which their logic led them.

Not so the Nazis. With the active and often enthusiastic participation of large portions of the German psychiatric profession, Hitler's minions copied the compulsory sterilization laws the United States had pioneered. Around 300,000 or 400,000 German patients were sterilized between 1934 and 1939.

(Margaret Smyth, a psychiatrist who headed Stockton State Hospital, boasted that they had only been able to accomplish so much 'in a scientific spirit... after careful study of the California experiment'.) And then the Nazi bureaucracy took matters a chilling step further. As early as the 1920s, German psychiatrists like Alfred Hoche had argued in favour of extinguishing 'useless lives'. The Führer issued a decree in October 1939 making mass extermination official state policy. Under the so-called 'T-4 programme', psychiatrists established 'review commissions' which marked mental patients for death, often referred to as 'disinfection'. At first, lethal injections were employed, but as the scale of the programme rapidly expanded, to facilitate matters gas chambers were built, disguised as showers, along with gas ovens to burn the corpses. Between January 1940 and August 1941, at death camps like Hadamar, 70,273 inmates bused in on what were

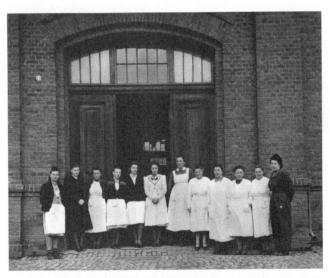

12. In their starched uniforms, the staff at Hadamar who conducted the mass killings of mental patients – or as the Nazis called them, 'useless eaters' – smile proudly at the camera

informally called 'killing crates' by the locals (the meticulous record-keeping was a feature of the regime) were suffocated with carbon monoxide gas, their gold teeth extracted, and their bodies burned in gas ovens. The killings by German psychiatrists would continue for some weeks after the Allies occupied the surrounding territory as the war drew to a close.

It was the mentally ill, therefore, who were the first victims of Hitler's Holocaust, the involuntary human guinea pigs used to develop the techniques then turned on the still larger group the Nazis saw as a threat to 'racial purity', the Jews. Indeed, some of the gas chambers first put to work to kill the mad were later disassembled and moved to the extermination camps devoted to the Final Solution in occupied Poland, the trained staff often accompanying them. In all, estimates are that between 200,000 and 250,000 mental patients perished in the space of little more than five years.

Chapter 4
Madness and meaning

The German psychiatry that played such a prominent role in murdering its patients had established itself as the most prestigious branch of the emerging profession in the second half of the 19th century, a period when German medicine in general was forging close links with science and the laboratory and was widely acknowledged to be the best in the world. In the French- and English-speaking worlds, mad-doctoring remained essentially an administrative speciality, and one shorn of any links to the university, to research, or to formalized training. Would-be psychiatrists learned their trade by apprenticeship, taking on unpaid junior positions in barracks-asylums, and then moving up the bureaucratic ranks little by little before eventually (they hoped) securing a position as asylum superintendent, whence they could rule, in autocratic fashion, over miniature kingdoms of the mad. But whatever degree of authority they purported to exercise in these Potemkin villages, they were locked away in them almost as securely as their charges. They remained conspicuously mired in the status of salaried employees, and were forced to confront and cope with a clientele composed of the least attractive members of the lower orders of society. Like similarly situated groups such as workhouse doctors and public health officers, they could lay claim to at best a tenuous hold on social respectability, and but a paltry measure of the autonomy usually granted to those engaged in professional work. Those who eschewed the public

asylums might move to the private sector and take charge of a profit-making madhouse, but that brought its own sort of stigma. For though the trade might prove lucrative, it was a grubby sort of business, too overtly tied to the pursuit of profit from speculating in human misery, too self-evidently at odds with the ideological construct of a disinterested profession.

By contrast, German psychiatrists pioneered a quite different mode of practice. Like their counterparts in internal medicine, they built solid ties to the world of the university and the laboratory. Indeed, the founding father of the German specialty was Wilhelm Griesinger, a man who had established his reputation as an expert on infectious diseases as professor of medicine at the University of Tübingen and subsequently as professor of pathology at Kiel, before becoming director of the Canton hospital and mental asylum at Zürich in 1860. Early in his career, Griesinger had spent a short period as a junior doctor at an asylum at Winnenthal, and in 1845 had audaciously published a textbook of psychiatry. At Zürich, he produced a vastly expanded second edition, and shortly thereafter moved to Berlin, finally occupying a chair in psychiatry.

Borrowing from the now well-established pattern in German medicine, Griesinger established a new model of practice, one that linked research and teaching via the university clinic. Asylums were relegated to being a source of clinical material, and it was the clinics and their associated laboratories and research institutes that became the core of a novel approach to medicalizing madness. Two decades earlier, Griesinger had proclaimed that all mental illness was brain disease. Henceforth, the German psychiatric enterprise that built on the foundations he had laid would embrace this speculative claim as the basis of a new science. With a new journal, the *Archiv für Psychiatrie und Nervenkrankheiten* (the *Archives of Psychiatry and Nervous Diseases*), basic research into brain pathology moved to the fore.

Griesinger was not around to see it, for within months of writing a truculent editorial for the first issue of the *Archiv*, he was dead of a ruptured appendix. Nonetheless, his view that psychiatry must 'emerge from its closed-off status as a guild and become an integral part of general medicine accessible to all medical circles' continued to inspire his colleagues, as did his insistence that 'patients with so-called "mental illnesses" are really individuals with diseases of the nerves and the brain'.

On one level, the results of this emphasis on brain pathology and on the centrality of the laboratory were impressive. German psychiatrists looked to be engaged in the same sorts of activities as their erstwhile medical colleagues. Focusing on anatomy, men like Flechsig, Alzheimer, Nissl, and Meynert (the latter working in Vienna) dedicated themselves to the study of the architecture of the brain and spinal cord. They developed techniques for fixing and staining brain tissues for microscopic examination, and occasionally, as with Alzheimer's discovery of the plaques and tangles in the brains of those with the illness that came to be named after him, they were able to uncover links between mental symptoms and underlying pathology of the tissues. But none of this basic science made any contribution whatsoever to clinical care, let alone cure. On the contrary, Alzheimer's disease was the model for German psychiatry's heavily pessimistic view of the therapeutic prospects of the mad.

For the overwhelming majority of mental patients, the aetiology of their disorders remained as mysterious as ever. The best efforts of all this laboratory science led nowhere. The claims about the connections between brain disease and mental illness remained an article of faith, not a demonstrable fact (just as they do for the most part today). 'Brain pathology' was, in truth, brain mythology. Moreover, the emphasis on supposed structural defects in the brains of the mad fed into the generalized despondency of the degenerationist era. German psychiatrists shared the conviction that mental illnesses were essentially untreatable diseases.

Though patients in the clinics of the general hospitals served as teaching material, the much larger numbers of chronic patients in the huge state asylums served only as a source of specimens for the microscope and the dissecting table, once they finally expired. Academic psychiatrists otherwise evinced no interest in them and abandoned them to their fate.

Emil Kraepelin had problems with his eyesight, precluding him from participating in the laboratory activities that preoccupied most of his colleagues. Perhaps consequently, perhaps not, he became increasingly sceptical of the claims of the cerebral pathologists, which he rightly saw as speculative and, ironically, not rooted in empirical findings, for all their asserted scientific rigour. He turned instead to the longitudinal study of the fate of the masses in the asylum, seeking to map the natural history of mental disorder. The upshot was the creation of a new nosology, a classification of types of mental illness that he spread through successive editions of an increasingly influential textbook. Where many had viewed madness or psychosis as a unitary entity, under Kraepelin's influence, henceforth the emphasis on its division into specific disease entities would mark the field. Most critical was the division between what were asserted to be two different forms of madness: dementia praecox (relabelled as schizophrenia in 1910 by the Swiss psychiatrist Eugen Bleuler, who saw it as not necessarily involving dementia or restricted to the young); and the at first no more than residual category of manic-depressive psychosis, held to be an only somewhat less pernicious, because sometimes remitting, form of mental illness.

If Kraepelin's views became clinical orthodoxy among institutional psychiatrists, they did not mark any fundamental break from the pessimism and biological assumptions that had come to mark the field – or from its embrace of eugenics, of which Kraepelin was a major proponent. Dementia praecox and its subtypes (hebephrenic, catatonic, paranoid) was by far the most important form of psychosis for Kraepelin and his followers, and it embodied

69

in its very name ('early dementia') the notion of irreversible clinical and cognitive decline. Kraepelin emphasized the presence of delusions and auditory hallucinations, disorders of thinking, and the flattening of affect. Here were patients exhibiting incoherence, agitation, and an inability to form relationships with others, their grossly disturbed thought processes eventually subsiding into an increasingly denuded mental universe. That their prospects of recovery were essentially nil only added to the gloominess that surrounded the diagnosis.

Talk of degeneration and dementia seemed to locate madness among the socially marginal, the poor, and the despised. In reality, mental disturbance observed no such social limits. Indeed, as madness drew more attention, and presumed experts on mental disturbance proliferated, so too did the range of conditions psychiatrists spoke of as akin to mental illness and within their sphere of competence. The French spoke of *demi-fous*, the half-mad, the English and the Americans of those dwelling on the borderlands of insanity, inhabitants of the shadowy region the British physician Mortimer Granville called 'Mazeland, Dazeland, and Driftland'. Here were still somewhat functional, often affluent, patients, desperate to avoid falling into the pit of the asylum, and simultaneously the source of perhaps more treatable and certainly more lucrative and socially desirable patients.

It was in this context that the ancient category of hysteria enjoyed new prominence in the last third of the 19th century. All across Europe and North America, women especially (though not exclusively) seemed to fall into fits, to be troubled with paralyses with no obvious physical cause, to exhibit extreme emotional instability, to utter cries and shrieks, and to resort to seemingly impossible physical contortions. The most flamboyant and dramatic enactments of this seeming epidemic of mental disorder were staged at a clinic in Paris, where the most famous neurologist in the world, Jean-Martin Charcot, served as master of

ceremonies. Here the half-mad disported themselves on cue before an audience of intellectuals, politicians, and demi-mondaines.

These occasions were, as one critic acerbically noted, a sort of 'vivisection of women', a hysterical circus with unmistakable erotic overtones, and thus, of course, immensely popular and widely publicized. Tuesday after Tuesday, the grand old man of French neurology acted as master of ceremonies, inducing a kaleidoscope of dramatic symptomatology with a wave of his hand and the force of his gaze. Hysteria was, he insisted, a real neurological disease, and those exhibiting it were indeed a degenerate lot. Yet for all Charcot's eminence, the whole enterprise had a disreputable air. The bane of *fin-de-siècle* medicine, the 'disease' that Philadelphia neurologist Silas Weir Mitchell despairingly called 'mysteria', was regarded by many contemporaries as a form of fraud or dissimulation; and hypnotism, the intervention on which Charcot relied to entertain and instruct his audience, was in their eyes no

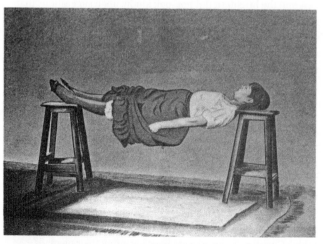

13. **A hysterical spasm of the entire body of Paule G, provoked by stroking her right forearm. Her rigid body spans two stools. An image taken from** *Leçons cliniques sur l'hystérie et l'hypnotisme* **(Paris, 1891)**

more than a relabelled form of mesmerism, long dismissed by respectable medical men as mere quackery. Unsurprisingly, on Charcot's death in 1893, his circus rapidly ceased operations, but the disease itself lingered on, though the epicentre of the disorder mysteriously drifted some hundreds of miles to the east, to a soon-to-be-famous set of consulting rooms at Berggasse 19 in Vienna.

Hysteria had been joined in the 1880s by a new mental malady of the affluent professional classes, neurasthenia – literally, weakness of the nerves – a mental disorder brought on, so its proponents claimed, by overwork and the pace of modern civilization. Overdrawing their stock of nervous energy, running down their batteries, bankrupting their brains – or so the theorists of marginal madness put it, in metaphors sure to flatter those they sought to attract and treat – the rich and the successful also succumbed to mental distress and breakdown. Naturally enough, these captains of industry and finance, these representatives of the best and the brightest, did not look kindly upon suggestions that they were a biologically inferior lot. Nor did they relish confinement in the warehouses of the unwanted that asylums had now become. Much more palatable was an alternative vision of the sources of mental disturbance that some now began to advance, among neurologists and other 'nerve doctors' on both sides of the Atlantic, one that sought explanations in the realm of human psychology, and treatment by psychodynamic means, preferably on an out-patient basis.

It would be wholly wrong to attribute this challenge to biologically based psychiatry as the product of one person. On the contrary, men like George Beard and Morton Prince in the United States, Paul Dubois in Switzerland, and Pierre Janet in France (to say nothing of religiously based mind-healing cults, like Mary Baker Eddy's Christian Science) were busy inventing their own explanations and interventions for these protean forms of mental upset. But nowhere were these innovations developed more

powerfully and effectively than in Vienna, where Sigmund Freud began to proclaim that madness had meaning – indeed, was produced at the level of meaning, and had to be cured at the level of meaning.

Based on the first few cases he treated with his older colleague Josef Breuer in the 1880s, Freud had largely abandoned what he came to regard as the somatic prejudices of his youth. His hysterical patients, he thought, were suffering from repressed traumatic memories, memories that provoked the symptoms they now manifested. And their symptoms, he initially surmised, could be relieved by recalling what had been driven underground. Utilizing hypnosis, as earlier repressed experiences surfaced, a process of emotional catharsis ensued, and the patient could be pulled back from the brink of insanity.

Freud rapidly lost his faith in hypnosis and the cathartic method, but not his conviction that the sources of the mental disturbances among his patients lay in 'murdered memories', or rather in thoughts too disturbing to admit to one's consciousness. In the hothouse atmosphere of *fin-de-siècle* Vienna, he gradually developed an ever more elaborate model of human psychology, one largely based on clinical encounters with a small number of, mostly female, patients drawn from the ranks of the Jewish haute bourgeoisie. It was a theory he and his followers came to see as equally applicable to the mad and the sane, the hysterical and the 'normal'. It placed sex at the centre of our very being, though it moved from an initial claim that actual seductions and sexual molestations were at the root of psychopathology to a subsequent emphasis on fantasy and the purportedly universal and critical impact of the child's hitherto overlooked 'erotic' relations with his or her parents.

Over the course of a decade, between 1895 and 1905, Freud developed the notion that the libido, the unconscious sexual drive, was the central psychological underpinning for all human beings.

All sorts of psychological discomforts and disturbances flowed from that fundamental reality, and from civilization's demands that these forces be channelled in 'acceptable' directions – a fraught process, and one that often remained incomplete and unsatisfactory. The nuclear family was the scene of often frightful and dangerous psychodramas that populated the unconscious, fomented its repressions, and created its psychopathologies. As the infant struggled to grow up, and the child to mature, the perils of Oedipal conflicts awaited – the unacknowledged and unacknowledgeable desire for an erotic relationship with the parent of the opposite sex – and too often wreaked havoc on the adult personality. Forced to repress unacceptable desires, to deny their fantasies, or to drive them underground, children were riven with psychic conflict. Cravings and suppressions, a search for substitute satisfactions, false forgetting, the constraints of 'civilized' morality – in all these respects and more, the conflict between Eros and Psyche created a minefield from which few emerged unscathed and unscarred. Madness was not just a problem of the Other, therefore, not a condition unique to the degraded and degenerate, but on the contrary, lurked to some degree within all of us. Sublimated in other directions and with greater success, the same forces that led one to mental invalidism allowed another to produce accomplishments of surpassing cultural importance. Civilization and its discontents were locked in an indissoluble embrace.

To say the least, these were controversial claims, and they were far from obtaining universal consent, either among Freud's fellow psychiatrists, or among the public at large. If they were taken seriously, however, they provided a very different perspective on the disturbed thoughts and behaviours of the mentally ill. Instead of being meaningless noise, the epiphenomenal manifestations of a physically damaged brain, psychoanalysis (as Freud's system came to be called) insisted that disturbed affect, cognition, and actions were of the utmost significance, and held the key to unlocking the wellsprings of madness. They provided clues that

might be pieced together to allow the patient to grasp the underlying dynamics of his or her disordered personality. Making manifest what the psyche invested so much energy in burying, so the psychoanalysts proclaimed, was a profoundly difficult task, one that took courage and determination on the part of both patient and therapist, and that inevitably required months, if not years, of probing deeply rooted defences to force the unconscious into consciousness. In place of the public theatre of Charcot's demonstrations, an intimate drama à deux materialized, one hidden behind the doors of the consulting room and the studied silence of the psychoanalyst.

Psychodynamic accounts of the origins of madness thus went hand in hand with a new emphasis on listening to the mad, and teasing out from their utterances the symbolic meanings of their symptoms, the psychological roots of their disturbance, and the means of reconstructing their damaged psyches. Though initially developed to diagnose and treat still ambulatory, if disturbed and distressed, neurotics, in succeeding generations, and most especially in North America, Freud's notion that madness and its cure were rooted in systems of meaning eventually was broadened to encompass even the most seriously psychotic. That was not an extension of which he personally approved, but after his death, it happened anyway.

Such was the cultural resonance of the psychoanalytic project, as it provided novel insight into human personality and human action, that soon its interpretations of the clash between Eros and Civilization leaked out of the realm of the pathological into discussions of the psychopathology of everyday life; and then into the arts. Freud himself had led the way in suggesting that psychoanalytic theory could be used to advance the interpretation of art, in speculative essays about Leonardo and Michelangelo, and his work was rife with literary allusions, beginning, of course, with the central concept of the Oedipus complex. Other psychoanalysts purported to trace the origins of scientific and

artistic creativity in the psychodynamics of the personality, and interpretations of the hidden symbolism to be found in painting and in fiction began to proliferate.

Reciprocally, artists and writers began to self-consciously play with Freudian themes. Painting, drama, advertising, and that quintessential 20th-century innovation, the movie, soon were saturated by Freudian symbolism and ideas. The Surrealists, in particular, overtly made use of Freudian ideas, and literary criticism, if not much of mainstream literature itself, seemed to import psychoanalytic ideas wholesale. Manuals of child-rearing warned sternly of the perils associated with toilet-training and psychosexual development. And the evils of Hitler and Stalin were the subject of psychoanalytic speculation, some of it even commissioned by the Office of Strategic Services, the direct ancestor of the modern CIA. In many quarters, madness had recovered its meanings with a vengeance.

Yet for many medics in the first half of the 20th century, the idea that mental disorders could be cured by talk, and that they were rooted in childhood sexuality, was not just unsettling, but positively absurd. The French largely responded by ignoring Freud and his followers as a species of Teutonic nonsense. Psychoanalysis would make no serious inroads in France until as late as the 1960s, and then only in the distorted and convoluted form pioneered by the would-be guru Jacques Lacan. Through the 1920s, the centre of psychoanalysis remained in the German-speaking world – in Vienna, Zürich, and Berlin. But whatever support Freud managed to secure there (and his system was viewed with little favour outside a restricted circle) was irretrievably lost with the rise of the Nazis, for whom his ideas were the very embodiment of degenerate Jewish 'science'.

Most British psychiatrists, led by men like Thomas Clouston and Sir Charles Mercier, were equally hostile and dismissive. For the most part, it was not sex as such, or any sense of prudery, that

motivated their opposition. They were willing to acknowledge that sex played a limited role in the genesis of some sorts of psychic disturbance. (Many had long postulated, for example, a causal link between masturbation and madness.) But that the libido was a universal cause of people's mental instabilities struck them as risible, and Freud's focus on what were widely regarded as perverted forms of sexuality (to say nothing of his perspective on family dynamics) was for these Edwardian gentlemen quite beyond the pale. To wallow in such filth in the analytic hour struck them as precisely the reverse of what was needed, for it encouraged the very sorts of morbid introspection that were a feature of madness. Psychoanalysis, as Sir Clifford Allbutt put it, was an 'odious' development. Freud, not to put too fine a point on it, was a fraud.

And what of America? Freud had famously visited the United States in 1909, but had dismissed both psychoanalysis's prospects in so crude a culture, and the country itself: 'America is gigantic, but a gigantic mistake.' It is a major historical irony, therefore, that it was here that psychoanalysis would establish, first a secure bridgehead, and then for some decades a dominant position, not just among professional psychiatrists, but in the culture more generally. At first, most Americans' exposure to psychoanalytic ideas came indirectly, through the efforts of the nascent advertising industry to sell using Freudian symbolism and appeals to the unconscious (to say nothing of a fixation on sex), and rather later through the penetration of Freudian ideas into Hollywood films. But once Benjamin Spock's *Baby and Child Care* became the Bible of how to navigate the perils of childhood, they were introduced to them much more directly, albeit in simplified and bowdlerized form.

Yet in the United States too, through the first four decades of the 20th century, the experts in the diagnosis and treatment of madness, and most certainly those amongst them who treated the inhabitants of America's mental hospitals, initially shared the scorn for psychoanalysis exhibited by their European

counterparts. And the disdain of institutional psychiatrists everywhere expressed itself, not just in verbal hostilities, but in a renewed commitment to a somatic interpretation of madness, made manifest in a veritable orgy of therapeutic experimentation on the vulnerable bodies of those who had been certified as mad. Drugs, electricity, malarial mosquitoes, and the surgeon's scalpel all now made an appearance as means of attacking madness at its alleged roots, if not the mad themselves.

A New Jersey psychiatrist, Henry Cotton, claimed to have discovered the sources of all forms of madness in chronic latent infections, hidden in the corners and crevices of the body, and pumping out toxins that poisoned the brain and disturbed both the emotions and the thought processes. In a pre-antibiotic era, that meant a resort to 'surgical bacteriology' – put more bluntly, surgical evisceration, as teeth, tonsils, stomachs, spleens, colons, and uteri were cast aside in the pursuit of focal sepsis. It was a deadly pursuit which nonetheless attracted not inconsiderable support for a time on both sides of the Atlantic. Cotton's notions even made a brief appearance in Scott Fitzgerald's *Tender is the Night*, and Fitzgerald had ample experience with the psychiatric universe at one remove, through the travails of his wife Zelda, who for a time was treated by Cotton's mentor and protector, the eminent Swiss-American Adolf Meyer.

The mistaken notion that seizures and schizophrenia could not co-exist prompted a search for suitable means to provoke artificial grand mal convulsions – using camphor, then metrazol (known in Europe as cardiazol), and finally electricity. Experiments with sleep therapy, designed to give the damaged brain time to recover, segued into experiments with using one of the true miracles of 20th-century medicine, insulin, to induce lengthy comas, from which, it was alleged for a time (till eventually controlled trials demonstrated it was a myth), as many as 80% of the schizophrenic could be reclaimed into the ranks of the sane. As one enthusiast of the time boasted,

we act with both [insulin and metrazol] as with dynamite,
endeavoring to blow asunder the pathological sequences and
restore the diseased organism to normal functioning...we are
undertaking a violent onslaught with either method we choose,
because nothing less than such a shock to the organism is powerful
enough to break the chain of noxious processes that leads to
schizophrenia.

Obsessed with the idea that fever might somehow clear the brains
of the deluded and distracted, a Viennese psychiatrist, Julius
Wagner von Jauregg, experimented with a variety of febrile agents,
include typhoid vaccine and the organisms responsible for
erysipelas and rat bite fever in order to validate his hypothesis,
before settling, late in the First World War, on the use of malaria to
provoke remitting fevers that could be cut short (if not always) by
the administration of quinine. Not long before, the origins of
general paralysis of the insane in infection with the syphilitic
parasite had been definitively demonstrated in the laboratory, and
it was to those afflicted with this dreadful disorder – which
produced a fearful combination of psychiatric and neurological
symptomatology, a steep physical decline, and a particularly nasty
end, demented, paralysed, choking on one's own vomit – that
Jauregg directed his ministrations. Perhaps it worked. Certainly,
clinicians of the era believed that it did (though the treatment
would be superseded by treatment with penicillin before ever it
was put to the decisive test of a controlled trial). And the Nobel
Committee rewarded Jauregg with one of its prizes, in 1927. But
Jauregg's conviction that other forms of insanity would yield before
the onslaught of fever therapy proved misplaced, and even though
many other psychiatrists experimented with diathermy machines,
instruments designed to break down the body's ability to maintain
a constant temperature, no other forms of psychosis responded.

Perhaps the most dramatic of these somatic interventions,
however, emerged in the mid-1930s, first at the inspiration of a
neurologist practising in the backwater of Lisbon, Portugal. Egas

Moniz proposed a direct assault on what most of his psychiatric colleagues had long considered the seat of madness, the brain itself. And he did so via an operation designed to destroy brain tissue, particularly portions of the frontal lobes of the brain, an operation he called a prefrontal lobotomy. Picked up by an ambitious American duo, the neurologist Walter Freeman and the neurosurgeon James Watts, faculty members at George Washington University Medical School, the new operation survived a rocky initial reception among American psychiatrists and was embraced in North America and across much of Europe and its dependencies. Freeman, in particular, worked tirelessly to proselytize for the miraculous operation that relieved one of care and took away the sting of psychosis. He operated on children as young as four years of age, and when the relative complexities of boring holes in the skull and using a neurosurgeon to slice through the white matter of the brain with something resembling a butter knife threatened to preclude the extension of its benefits to the thousands of patients languishing on the back wards of mental hospitals, he popularized a different technique. Using an ice pick and a mallet, having reduced the patient to unconsciousness with a rapid series of electrical shocks to the brain, he attacked the brain via the eye-socket, puncturing the orbit and with sweeping motions severing the fibres he was convinced lay at the root of mental suffering.

Moniz would win the second Nobel Prize for Medicine awarded for a psychiatric intervention in 1949 for an operation that would subside into near-oblivion over the next decade or so. Its very name would come to symbolize psychiatry run amok. Walter Freeman, once dubbed by *Time* magazine as the man with the golden ice-pick and lauded in the pages of the *New York Times* by its science correspondent, would end his days retired to California, isolated and increasingly reviled as a moral monster.

The human brain is a remarkably resilient organ. Even under these assaults, some semblance of humanity sometimes survived

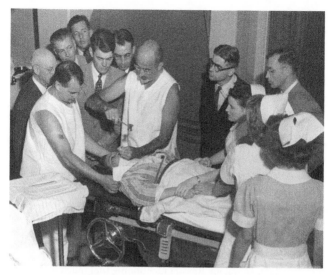

14. Walter Freeman performing a transorbital lobotomy at the Western State Hospital, Fort Steilacoom, Washington, 8 July 1949. The patient has been rendered unconscious by two electroshocks to her brain, administered in rapid succession, and Freeman is using a mallet to drive an ice-pick-like device through the eye socket into the frontal lobe of the brain

amongst those who underwent the operation. A number of those tortured by obsessions and compulsions that had dominated their lives found some surcease. The schizophrenic, as Freeman frankly admitted, still heard voices and hallucinated, but for some patients, the force of these disturbances was lessened. Some psychiatrists, patients' families, and even patients themselves, interpreted such outcomes as improvements over the prior madness. Not everyone, in other words, was reduced to the status of a zombie or human vegetable, as later generations would come to believe (though many indeed were, and languished as burnt-out cases on the 'continuous treatment' wards of the local mental hospital). But all were permanently brain damaged, and badly so, their capacity for empathy, for

forethought, for self-restraint, in many ways, their most centrally human qualities, irretrievably lost.

It has become fashionable in some scholarly circles to suggest that perhaps lobotomy was not so bad after all; that its proponents ought to be cut some slack, given the grim clinical realities that they confronted in the 1930s and 1940s; that after all, many of them acted with the best of intentions and within the limitations of the science of the times. For others, the lobotomy era is symbolic of how society's efforts to grapple with the nightmare that is severe mental illness seems at times to license remedies that are worse than the disease, interventions that themselves almost appear to constitute a form of madness. As is doubtless apparent, my sympathies, at least, belong with the latter camp, those who seek to obey the ancient Hippocratic command: 'First do no harm.' And whatever one's ultimate judgement about the merits of Freud's system, it bears mentioning that much of the professional opposition that persisted even in lobotomy's heyday came from the ranks of the psychoanalysts. For those who saw madness as rooted in meaning, taking an ice-pick to the frontal lobes was a category mistake, as well as an act of barbarism.

Chapter 5
Madness denied

The exceptional violence and mass slaughter that characterized much of the 20th century had dramatic effects on cultural perceptions of madness, and on the fortunes of the professionals who claimed the authority to define and treat it. The two world wars in particular, and the post-colonial wars in Vietnam and the Middle East to a still significant extent, were marked by epidemic levels of mental breakdowns among the fighting forces – the shell shock of trench warfare; the combat exhaustion and war neurosis of the fight against Hitler and Hirohito; the post-traumatic stress disorder among the defeated American army in Vietnam; and the mysterious ailments that were gathered together under the catch-all title of 'Gulf War syndrome' in the 1990s and beyond. All posed huge problems for the military machines during the fighting, and for the civilian authorities in war's aftermath. They simultaneously did much to transform the psychiatric enterprise, and to alter the terms of psychiatric discourse. The Second World War, in particular, prompted a massive expansion of the psychiatric profession, the creation of competing kinds of psychotherapists and clinical psychologists, and the beginnings of a massive shift in the locus of psychiatric care – to say nothing of its effects on the way ordinary people looked at mental illness.

The 'shell shock' crisis of the First World War had provided the first inkling that modern industrialized warfare was not ideally suited

to the maintenance of mental health among the troops. Within months of the start of the fighting, a military stalemate had ensued. Trapped in the Flanders mud, soldiers in trenches waited for death – from high-explosive shells, from flesh-tearing bayonets, from machine-gun bullets, from poison gas. No army was spared the epidemic of nervous disorders that followed. By their thousands and tens of thousands, soldiers were struck dumb, lost their sight, became paralysed or incapable of normal motion, wept, screamed uncontrollably, lost their memories, hallucinated, were rendered sleepless and incapable of fighting. As the very name 'shell shock' suggests, many military psychiatrists initially thought, in keeping with the somatic theories that still were the ruling orthodoxy of their profession, that the disorders were the manifestation of real damage to the nervous system produced by the blast from high explosives. But such claims increasingly seemed implausible and even untenable. Soldiers who had not even reached the front lines became symptomatic. Those who became prisoners of war, and thus immune from the tensions of life in the trenches, never did. The military high command on both sides of the fighting saw in these findings evidence that the victims were simply cowardly malingerers, and some of the sadistic treatments meted out by their physicians – torture with electric currents applied to tongues and genitals, for instance – seem to have reflected a similar hostility on their therapists' part, or a simple determination to force them back to the fighting. But the preternatural tenacity with which shell shock victims clung to their symptoms made simple claims of malingering hard to sustain. The Germans adopted the label *Schreckneurose*, or terror neurosis. Trauma and psychological stress, it seemed, could cause even the apparently stable to break down, to become maddened with fear, disgust, horror.

History repeated itself less than a quarter-century later, when total war erupted once more, and it did so despite efforts by the psychiatric profession to screen out the emotionally unstable before conscripting them for military duty. Once more, the horrors

of the battlefield caused men to break down. Once more, madness came to seem a psychological disorder, and one not confined to the degenerate and defective, but a condition to which all were susceptible if placed under sufficiently appalling psychological stress. At war's end, 50,000 psychiatric casualties were crowded into American military hospitals alone, and nearly half a million GIs were receiving pensions for psychiatric disabilities by 1947.

If the epidemic of shell shock had given broader credibility to the idea that at least some forms of mental breakdown had a psychodynamic aetiology, the experience of the Second World War (and of Vietnam some decades later) appeared to confirm it. Nowhere was that more the case than in the United States. Indeed, the almost unique power and cultural authority psychoanalysis obtained for a time in America – a hegemony it won almost nowhere else except for peripheral exceptions like Argentina – was in substantial measure a product of the impact of war on American troops, and the efforts of military doctors to treat them.

Freud's 1909 visit to Massachusetts had won psychoanalysis some influential converts – men like the Harvard neurologist and New England Brahmin James Jackson Putnam, William Alanson White, the superintendent of the enormous federally run St Elizabeth's mental hospital in Washington, DC, and his friend Smith Ely Jeliffe, editor of the *Journal of Nervous and Mental Disease*. Though clearly a minority taste among the nation's psychiatrists, psychoanalysis had established a significant bridgehead among the rich and chattering classes, and the numbers of analysts (and their internal divisions) had multiplied in the late 1930s as psychoanalytic émigrés fleeing Hitler's murderous regime arrived as refugees in New York. But it was the Second World War that transformed its standing, and vaulted it from the sort of marginal position it occupied in most European societies into a commanding position at the apex of American psychiatry, a position it would sustain for a quarter-century and

more after the end of hostilities. By 1960, every major academic department of psychiatry in the United States would be chaired by a psychoanalyst or a psychoanalytic fellow traveller, with the single exception, if exception it be, of the department at Washington University in St Louis, Missouri. And the link between psychiatry and the couch had been firmly established in the popular imagination, where it remains to this day, as the cartoons about mad-doctors in the *New Yorker* regularly remind us.

William Menninger, a charismatic figure from Topeka, Kansas, had been appointed as head of military psychiatry at the outbreak of the war. At his family asylum in the 1930s, which he ran with his brother Karl, a bowdlerized, Americanized version of psychoanalysis had been the therapeutics of choice, and faced with a new massive epidemic of what were seen as psychological casualties, it was to brief, rapid, and simplified psychotherapeutics that Brigadier General Menninger's underlings now turned. New medical recruits were rapidly trained to administer the treatments, and the number of psychiatric practitioners exploded, doubling over the course of the war years. Nor did psychiatric problems disappear with the outbreak of peace (or rather of the Cold War). In many ways, they appeared to intensify, and those who had entered upon psychiatric practice as a matter of wartime necessity sought in many instances to make the transition to civilian practice – a transition greatly aided by the substantial sums the federal government began to provide to pay for the training of apparently urgently needed professionals.

It was Menninger's Young Turks who seemed to be the promising future of a new, psychoanalytically inclined profession. In battles with the old guard who still lurked in traditional mental hospitals, and who were now treating a half million in-patients and more on an average day, they exhibited their intellectual disdain and their numerical muscle, electing Bill Menninger as the president of the American Psychiatric Association in 1948. Later that year, a

portrait of the great man appeared on the cover of *Time* magazine, alongside a diagram of a human brain, complete with key and keyhole. It was a fitting symbol of the rapidity with which psychoanalytic ideas about madness had captured the American imagination and spread into American popular culture. To be sure, there were dark mutterings among Freud's displaced circle of European exiles in New York that the crude American and his badly trained followers were betraying the sophisticated pessimism that their revered father-figure had articulated, in favour of a feel-good, emasculated version of psychoanalysis. But beyond that small circle of true believers, some more attractive, optimistic version of Freud's ideas was on the march, spilling out of the realm of the pathological into discussions of the psychopathology of everyday life, and then into the arts – into painting, novels, and movies. Above all, into movies.

As early as 1919, the German director Robert Wiene had produced a classic picture of madness on the screen. The plot of *The Cabinet of Dr Caligari* originally portrayed the psychiatrist at the local lunatic asylum as a sinister figure using a sleepwalker who is under his control to commit serial killings. Visually, the impression of entering the nightmare world of the violent madman was heightened by setting the action in front of painted sets, all sharp angles, surreal architecture, deformed views, and distorted shapes. Late in the production, the director opted for a different, twisted ending, revealing that the portrait of the murderous mad-doctor was in 'reality' the delusion of one of the asylum's patients (a twist in the plot that would resurface in other films with more mainstream appeal, for example, in Hollywood's version of the schizophrenia of the founder of game theory John Nash, *A Beautiful Mind*). *The Cabinet of Dr Caligari* prefigured an enduring fascination with the theme of madness among film makers. It was a fascination in full flower throughout the period when psychoanalysis dominated American psychiatry, and Freudian images of psychiatry would persist in American film even when the profession itself moved on.

The back wards of America's decaying state hospitals were the setting for one of the five most popular movies of 1949, *The Snake Pit*, starring Olivia de Havilland as a housewife with a father fixation. Unable to perform her wifely duties, she tumbles into madness, and seems destined to rot in an overcrowded asylum, till she is rescued by a handsome young psychiatrist. Lying on his couch, with a portrait of St Sigmund in the background, she relives her childhood, comes to see the sources of her breakdown, and is miraculously cured, though not until she has displayed an unseemly erotic interest in her doctor – a Freudian transference – from which she finally emerges a happy and suitably loving spouse, strolling off into the sunset with her husband, presumably towards domestic bedded bliss.

Three decades later, Joanne Greenberg's roman-à-clef, *I Never Promised You a Rose Garden*, was transferred to the screen, and audiences were treated to another portrait of a schizophrenic young woman, this time in a ritzy private asylum (in reality Chestnut Lodge in Maryland). Hallucinating, self-mutilating, angry, and uncooperative, trapped in an alternative world of fantasy, pain, and self-imposed degradation, the adolescent Deborah Blake is delivered to her confinement by her parents – an ineffectual father figure dominated by an icy, controlling wife. Again, she is rescued by a caring Freudian – Bibi Anderson playing Dr Fried (in real life Frieda Fromm-Reichmann) – and by talk therapy that, in revealing the traumatic sources of her breakdown, brings her back to a world of sanity.

Best-selling pot-boilers like Robert Lindner's *The Fifty Minute Hour* purported to give a less glossy and fictionalized, but in reality equally manicured and romantic, view of the magic that could be wrought on the couch. Americans learned that madness could touch even the affluent, that modern psychiatry could make sense out of seeming nonsense, and that the surgical probes of the analyst could reveal the unconscious roots of mental disturbance and magically help patients discover the repressed memories that

had made them psychotic – a catharsis that at once made them better. It was a lovely fantasy.

Freudian notions were embodied, too, in such otherwise remarkably different films as John Frankenheimer's *The Manchurian Candidate* (with Angela Lansbury's chilling portrait of the brainwashed Robert Shaw's mother); Nicholas Ray's *Rebel Without a Cause* (with James Dean's rebellious teenager the product of his overbearing mother and his weak, emasculated father); and Robert Redford's *Ordinary People* (in which Mary Tyler Moore plays the bitter and soulless Beth Jarrett and Donald Sutherland her hopeless, ineffectual husband Calvin): all embody some of the central themes running through post-war Freudian speculations about madness and antisocial behaviour more generally. Psychiatry was expanding by leaps and bounds in the quarter-century after the war – from a total of fewer than 5,000 psychiatrists in 1948, their numbers had grown to more than 27,000 by 1976. Most of the new specialists were psychiatrists of the couch, practising on affluent and well-educated out-patients with neurotic symptoms, and disdaining contact with the poorer and more desperately disturbed patients who still crowded the wards of the state hospitals.

By the end of the 1950s, psychoanalysts comprised one-third of the nation's psychiatrists, and by 1973, they were numerically in the majority. Moreover, these raw numbers underestimate their impact, for those working within this tradition occupied the commanding heights of the profession, dominating most academic departments of psychiatry, and creaming off the most talented of the profession's new recruits for their chosen approach to treating mental illness, one that was almost entirely psychological. Their patients were less disturbed and much more socially desirable, and their incomes higher than those accruing to many other branches of the medical profession. Meanwhile, the less talented half of those emerging from psychiatric training were packed off to practise in the mental hospitals and public clinics

where, for a stigmatized clientele, they provided a stigmatized, second-class variety of psychiatry (so-called 'directive-organic psychiatry'), perforce relying on brief contacts with patients for whom they prescribed pills and administered shock therapy.

But the psychotic were, after all, the maddest of the mad, and a few brave (or foolhardy) analysts like Harry Stack Sullivan and Frieda Fromm-Reichmann sought to treat them (or the more well-to-do among them), while still others sought to provide Freudian accounts of the sources of their disturbance. Articulated most persuasively perhaps, and certainly at greatest length, by Silvano Arieti, in a book whose second edition won a National Book Award for science in 1975, the psychoanalytic account of the most feared and pernicious of psychiatric diagnoses, schizophrenia, predictably is rooted in the psychopathology of family life. Drawing on a notion first advanced by Leo Kanner in 1949, that the roots of autism lay in absent fathers and mothers who displayed 'a distinct lack of maternal warmth' (parents who, as he put it a decade later, unfortunately 'just happen[ed] to defrost enough to produce a child'), psychoanalysts like Fromm-Reichmann had articulated the notion of 'the refrigerator mother'. This schizophrenogenic figure, 'domineering, nagging, and hostile, ... gives the child no chance to assert himself, [and] is married to a dependent, weak man, who is too weak to help the child'. Hence, Arieti claimed, 'adolescence was a crescendo of frustration, anxiety, and injury to self-esteem', followed by a collapse into inertia and madness. Living in an unbearable reality, the schizophrenic retreated into an alternative, pathological territory of his or her own making, a world whose meanings could only be teased out by carefully tracing their origins in the cruelties of the domestic sphere – cruelties the parents, of course, did their utmost to deny, to themselves quite as much as to outsiders.

These notions are all oddly reminiscent on some level of ideas advanced by the controversial Scottish psychiatrist R. D. Laing – oddly, because Laing's perspective is more usually seen as deriving

from his romance with existential philosophy, and he is widely regarded as one of the founders of what others came to call 'anti-psychiatry'. Certainly, he was no ordinary British psychiatrist, for the mainstream of the profession in that country continued to embrace an eclecticism that nonetheless implicitly endorsed biological perspectives on major mental disorders. But the Freudian overtones of Laing's early work, and its overlap with the theorizing of American psychoanalysis trying to account for schizophrenia, should really occasion little surprise, for after all, Laing had trained at the centre of the embattled English psychoanalytic establishment, the Tavistock Clinic.

The Divided Self, published in 1960, saw the schizophrenic as suffering from a profound ontological insecurity, itself produced by a toxic upbringing whereby parents, particularly mothers, placed children in impossible double binds (a concept he had borrowed from Gregory Bateson). Schizophrenics' seemingly nonsensical symptoms (beliefs that they were made of glass, that they were Jesus reincarnated, that they were being persecuted, that they were already dead), could in reality be rendered meaningful by a suitably sympathetic observer, for they expressed in distorted form patients' struggles to cope with an unbearable, impossible interpersonal environment. Their symbolism needed decoding, and that process could conduce to a cure. A few years later, he and Aaron Esterson would further implicate the lies and deceptions, the pathological patterns of communication and exclusion, they alleged were to be found among the parents of schizophrenic girls in the genesis of 'madness', or rather the process of collusion through which, they claimed, the child was labelled pathological and then locked in that role.

Laing would in short order move in stranger directions, towards the claim that the mad were somehow the super-sane; that schizophrenia was a voyage towards a superior reality; that it was society that was sick, not the mental patient. 'Future generations', he predicted, 'will see what we call "schizophrenia" was one of the

forms in which, often through quite ordinary people, the light began to break through the cracks in our all-too-closed minds'. In steadily more vituperative terms, he assaulted the neurobiological accounts of mental illness and its treatment that were embraced by most of his nominal colleagues, and attacked mainstream psychiatry. When as patients we are marched into the psychiatric case conference, he claimed, 'We are mentally dismembered. Raw data go into the machine, as once raw human meat into the mouth of Moloch.' It was a doctrine that in the 1960s and into the 1970s brought Laing worldwide fame outside the ranks of his profession, where suspicion of psychiatry was steadily on the rise. But his fellow psychiatrists mostly responded by branding his work as self-indulgent and methodologically flawed. Why, they asked, had he and Esterson only studied patterns of interaction among families with a mentally ill member? How did they know that the behaviours they claimed to observe had produced the illness, rather than emerging in response to it? Where were the control studies of interactions in 'normal' families? His ideas, they sniffed, were the product of a narcissist, interesting fairytales of little or no practical value when it came to grappling with the grim realities of life on the mental hospital ward.

The gibe that as therapy Laing's ideas were useless carried considerable weight, for his efforts to put into practice the idea that schizophrenia was a voyage of discovery that should be indulged in and encouraged generally had disastrous results. It was, however, a criticism that equally could be (and increasingly was) levelled against Freudian psychiatry as a whole, however attractive it seemed to many as an intellectual system. Even among the mildly disturbed, its ministrations seemed interminable, and the relief it supplied from mental distress ephemeral at best. Among the more seriously distressed, it had promised much and delivered little. Just as Freud himself had predicted, the talking cure (impractical as it would in any event have been in asylums that locked up indigent patients in their thousands) proved spectacularly incapable of relieving the

miseries of most schizophrenics and manic-depressives. Laing's criticisms were only one symptom of an emerging crisis of psychiatric legitimacy, one that for a time seemed to deny, not just the status of psychiatrists as our society's credentialed experts on madness, but madness itself.

From many sides, the 1960s and 1970s saw assaults on psychiatry's pretensions and its claims to expertise in the management of mental illness. An emerging mental health bar launched scathing attacks on the profession's diagnostic competence. It was a soft target. Psychoanalysts evinced little concern for diagnostic labels and for 'descriptive' psychopathology of a Kraepelinian sort (yet another point of convergence with Laing), and psychiatric diagnoses were notoriously unreliable. As the issue began to be systematically studied in the 1960s, partly at the behest of pharmaceutical corporations trying to secure homogeneous populations on which to test new drugs targeted at treating the mentally ill, so a set of embarrassing findings piled up. Even with respect to what were regarded as the most serious forms of psychiatric disturbance, different psychiatrists agreed upon the diagnosis about 50% of the time. International comparisons demonstrated that what British psychiatrists diagnosed as manic depression, their American counterparts were prone to label schizophrenia, and vice versa. One prominent law review article suggested that psychiatric 'expert' testimony was nothing of the sort, but was rather akin to 'flipping coins in the courtroom', and marshalled an abundance of references to prove it. Soon the lawyers moved on to other targets. The involuntary commitment of psychiatric patients was likened to incarceration, only justifiable (if at all) in return for effective treatment. But the situation in many state hospitals was so parlous that there was essentially no treatment being provided. So there were lawsuits urging that states be required to provide therapy or else to discharge the patients, and suits over the right to treatment were soon followed by suits urging the recognition of a right to refuse treatment.

Feminists entered the fray. They had much to work with. The forces of sex and madness have been historically linked together in a multitude of ways. Notoriously, psychodynamic theories of mental disorder, particularly those of a Freudian provenance, accorded pride of place to sexuality in accounting for the aetiology of mental disorder. Freud's doctrine of penis envy, his bullying and worse of his female patients, and his evident puzzlement about what women wanted made him a target (though simultaneously, and perhaps perversely, some feminist theorists like Juliet Mitchell and Nancy Chodorow proclaimed themselves Freudians). Organically inclined 19th-century psychiatrists had provided their own accounts of the linkage, ranging from neurological portraits of females as possessed of nervous systems of greater refinement and delicacy (and hence more susceptible to breakdown) to gynaecological theorizing about the peculiarly intimate connection that supposedly existed between a woman's reproductive organs and her brain, theories that on more than one occasion had licensed mutilating operations to 'cure' female madness.

A new generation of feminist writers came to view psychiatrists as quintessential male oppressors, utilizing psychiatry to reinforce patriarchy. On the one hand, women were portrayed as disproportionately victimized by a male-defined double standard of mental health, which unwarrantedly and disproportionately, so it was claimed (though the evidence for this proposition was weak) assigned them to the highly stigmatizing status of the psychiatric patient (particularly if they behaved in ways that challenged masculine stereotypes about female propriety). Alternatively (though some found ways to advance both propositions), the oppressions, constrictions, and limitations of the female role in a patriarchal society were so damaging to the psyche, so stressful and harmful, that they drove a large number of women mad. Madness, the eminent literary critic and psychiatric historian Elaine Showalter proclaimed, was 'the female malady'.

In the realm of fiction and film, some international best-sellers later made into movies brought such ideas to a still wider audience. Jean Rhys's *Wide Sargasso Sea* (1966) reworked one of the most powerful literary portraits of female madness, Bertha Mason from Charlotte Brontë's *Jane Eyre*, into a colonial context. Her remarkable re-imagining of the earlier novel recast it into a very different context, the Caribbean of the 1830s as well as the Thornfield House of England and Jane Eyre; and her central character, Antoinette/Bertha Cosway/Rochester, brought questions of other kinds of oppression – colonialism, and race – into the equation, alongside the portrait of a woman stripped of her name and her very identity who ultimately plunges into madness, her spirit crushed by an oppressive male world.

Wide Sargasso Sea enjoyed extraordinary critical success. But its influence was perhaps exceeded by Sylvia Plath's roman-à-clef, *The Bell Jar* (1963), originally published under a pseudonym. Plath's own depression and hospitalizations, as well as her treatments with electroconvulsive therapy, are central elements in the story, as is her battle to become a woman in the world of the 1950s, where the choices on offer – suburban motherhood, or blue-stocking spinsterhood – seem equally unappealing. Self-hatred and confusion, ambition and a sense of worthlessness, fear of death yet acting in ways that court it, and in the background a 'self-sacrificing' vampire mother whom she finds hateful in ways she has a hard time acknowledging – these are some of the themes that run through the novel. But it was not so much its literary qualities as it was Plath's tragic death from suicide that ensured the book's iconic status. Just weeks after its appearance, to what she judged a cool critical reception, oppressed by financial worries and a failing marriage to the poet Ted Hughes, Plath put her children to bed and her head into a gas oven. A victim – but of what? Of the feminine mystique? Of a philandering husband? Of a refrigerator mother? Or of psychiatry's failures, and (male) psychiatric power and oppression?

There seemed to be no end to the assaults and the embarrassments psychiatry suffered in these years. A Stanford psychologist, David Rosenhan, conducted a study subsequently published in the august pages of *Science* that made use of pseudo-patients to impeach psychiatry's clinical competence. The research subjects showed up at their local mental hospital claiming to be hearing voices. Once admitted, they were instructed to behave perfectly normally. Most were diagnosed as schizophrenic, and their subsequent conduct interpreted through that lens, so the chart of one subject who wrote down details about the ward recorded that 'patient engages in writing behavior'. Fellow patients saw them as shamming, but not their psychiatrists, and when eventually discharged, many were given the parting gift of being labelled as 'schizophrenic in remission'. Psychiatrists protested loudly that the study was unethical and the methodology flawed, but 'On Being Sane in Insane Places' was widely seen as yet another black eye for the profession.

In the immediate aftermath of the Second World War, when conditions in mental hospitals were particularly dire, a series of sensational journalistic exposés had appeared, most famously Albert Deutsch's *Shame of the States*. Many were written by people who had recently visited the German death camps, and they explicitly compared the state of the back wards of America's asylums to Dachau, Belsen, and Buchenwald. Deutsch, for example, described the male incontinent ward at Philadelphia's Byberry State Hospital as:

> like a scene out of Dante's Inferno. Three hundred nude men stood, squatted, and sprawled in this bare room, amid shrieks, groans, and unearthly laughter . . . Some lay about on the bare floor in their own excreta. The filth-covered walls were rotting away.

For all the hyperbole that marked their critiques, these muck-raking journalists had sought the reform, not the abolition, of the asylums. Their explicit goal was to pressure politicians to spend

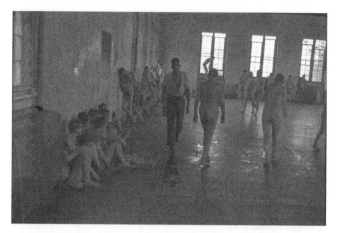

15. The men's chronic ward at Byberry State Hospital, a surreptitious image taken by Charles Lord, a Quaker conscientious objector assigned, like 3,000 others during the Second World War, to work as attendants in state mental hospitals. This was merely one of a series of searing images Lord published in *Life* magazine in May 1946. He subsequently became a social worker and a professional photographer

more money on the system, so as 'to put an end to concentration camps that masquerade as hospitals and to make cure rather than incarceration the goal', as Alfred Maisel put it in the pages of *Life* magazine. Not so their sociological successors, who produced a string of monographs on mental hospitals through the 1950s and into the 1960s that evinced a steadily mounting hostility to such places, and towards the psychiatrists who ran them.

The emerging consensus among the sociological fraternity was articulated most forcefully and powerfully, however, by Erving Goffman. Following three years on staff at the NIMH Laboratory of Socio-Environmental Studies, including a year of Institute-supported fieldwork at St Elizabeth's Hospital in Washington, DC, long considered one of the nation's finest, and the only mental hospital operated directly by the Federal Government, Goffman

provided a wide-ranging condemnation of the mental hospital as an anti-therapeutic invention. It was, he asserted, a 'total institution', one where the normal boundaries between work, sleep, and play were broken down, and where the caste-like interactions between different levels of the staff and between staff and patients created an artificial and massively damaging environment. Indeed, Goffman asserted, the most crucial factor in forming the mental patient was his institution, not his illness. Life on the mental hospital ward tended inexorably to damage and dehumanize its inmates, who were 'crushed by the weight' of what, on close inspection, was essentially a 'self-alienating moral servitude'. Their reactions and adjustments, pathological as they might seem to an outsider, were best seen as the product of their cruel circumstances. And since the defects that produced these behaviours were structural features of all such establishments, they were not removable by any conceivable set of reforms.

A decade later, Goffman was no kinder about these places. They were, he asserted:

> hopeless storage dumps trimmed in psychiatric paper. They have served to remove the patient from the scene of his symptomatic behavior... but this function has been performed by fences, not doctors. And the price that the patient has had to pay for this service has been considerable dislocation from civil life, alienation from loved ones who arranged the commitment, mortification due to hospital regimentation and surveillance, permanent post-hospital stigmatization. This has not merely been a bad deal; it has been a grotesque one.

In *Asylums*, Goffman's other examples of total institutions included prisons and concentration camps. The implied rebuke of psychiatry's therapeutic pretensions could scarcely have been more pointed or blatant, and it was intensified in the book's final chapter, where psychiatrists are derisively mocked as members of a 'tinkering trade' in whose hands 'reality must be considerably

twisted' to maintain the polite fiction that they are performing a therapeutic role. Day after day, hour after hour, 'inmates and lower staff levels are involved in a vast supportive action – an elaborate dramatized tribute – that has the effect, if not the purpose, of affirming that a medical-like service is in progress here and that the psychiatric staff is providing it'. But it has all the characteristics of a shell-game, and 'something about the weakness of this claim is suggested by the industry required to support it'. For, to venture 'a sentimental sociological generalization…: the farther one's claims diverge from the facts, the more effort one must exert and the more help one must have to bolster one's position'.

The growing intellectual distance, even outright hostility, between the two disciplines that is evident in both the language and the substance of this harsh assessment would only intensify over the next two decades. For if Goffman had scorned one of psychiatry's central institutions and attacked the capacities of psychiatry itself (and done so in a book that enjoyed an enormous audience in his own profession and even beyond), within a few years, other sociologists were advancing a still more radical notion, that mental illness was not an illness at all. Rather, it was simply a matter of labelling.

Drawing on the resources of so-called 'societal reaction theory', the California sociologist Thomas Scheff provided the most elaborate version of this 'fresh look at the problem of mental disorder'. 'There is as yet', he asserted, 'no substantial, verified body of knowledge…there is no rigorous knowledge of the cause, cure, or even the symptoms of functional mental disorders'. The whole body of psychiatric 'knowledge' was thus a carefully constructed sham. We would do better to adopt 'a [sociological] theory of mental disorder in which psychiatric symptoms are considered to be labeled violations of social norms, and stable "mental illness" to be a social role' – and to recognize that 'societal reaction [not internal pathology] is usually the most important determinant of

99

entry into that role'. Psychiatrists were just the most powerful official labellers. And so far from being a condition akin to tuberculosis or cancer,

> mental illness may be more usefully considered to be a social status than a disease, since the symptoms of mental illness are vaguely defined and widely distributed, and the definition of behavior as symptomatic of mental illness is usually dependent upon social rather than medical contingencies.

Psychiatrists confronting the pathologies that accompany severe mental disturbance saw such claims as absurd, if not insulting. In their eyes, such talk was not just anti-psychiatry, but anti-science, and dialogue with those espousing views of this sort was essentially pointless. But they had a traitor in their own midst: Thomas Szasz, trained as a psychoanalyst, and Professor of Psychiatry at the State University of New York at Syracuse. In 1960, Szasz published a polemic whose very title, *The Myth of Mental Illness*, signalled his dismissal of the whole notion of psychiatric illness as 'scientifically worthless and socially harmful'. Illness, he declared, was a simple defect of the body, and that was what doctors treated. 'Mental illness' was a metaphor, for there was no underlying somatic disease, and the concept referred only to 'problems in living', or difficult people whom society needed to control. Under the guise of 'helping', psychiatrists were actually agents of social control, nothing more than gaolers who masked what they were up to with medical language. And these simplistic claims, endlessly repeated by Szasz and his epigones over the decades that followed, inflicted yet further damage on psychiatry's public image.

As any sociologist worth his or her salt could tell you (and as every psychiatrist ruefully knows), one of the dubious rewards that flows from trading in lunacy is a share in the stigma and marginality we visit on those unfortunate enough to lose their wits. By the mid-1970s, mad-doctors must have thought they had received the

largest share. Hollywood echoed the mood. Milos Foreman's *One Flew Over the Cuckoo's Nest*, based on Ken Kesey's cult novel with the same title, appeared in 1975 and promptly swept all five major Academy Awards: best picture, best director, best actor, best actress, and best screenplay. Here was a damning portrait of the mental hospital and those who ran it. The patients are victims of the mental health machine, not of their psychopathologies. The hospital is an inhuman environment that damages and destroys. Psychiatric treatment is at best punishment, whether in the form of the dehumanizing group therapy sessions sadistically employed to destroy patients' sense of self, or in the convulsions produced by the electroshock machine that are used to punish misbehaviour. At worst, as with the lobotomy visited upon the otherwise indomitable character of Randle P. McMurphy, played by Jack Nicholson, it is a device to tame, to eliminate the individual, by reducing him to a human vegetable. Psychiatry, in short, is a sham, and perhaps something far worse, the ultimate means of enforcing conformity.

Chapter 6
Madness cast out

At the beginning of the 1970s, psychoanalysis ruled the roost, at least in the United States. And then it didn't. More swiftly and silently than the Cheshire cat, psychoanalytic hegemony vanished, leaving behind not a smile, but a fractious group of Freudians and neo-Freudians who squabbled in classically sectarian fashion among themselves. Professors of literature and anthropology tried feverishly to fend off the notion that Freud had turned into an intellectual corpse, but cruel realities suggested otherwise. Psychoanalysts were rapidly defenestrated, their hold over academic departments of psychiatry removed and replaced by laboratory-based neuroscientists and psychopharmacologists. Psychoanalytic institutes found themselves bereft of recruits and forced to abandon their policy of admitting only the medically qualified (a position they had long held to, though it had been explicitly repudiated by the Master). The term 'neurosis' was expunged from the official nomenclature of mental disorder (along with the category of 'hysteria', the condition that had given birth to the talking cure). The 'surface' manifestations of mental diseases that the psychoanalysts had long dismissed as merely the symptoms of the underlying psychodynamic disorders of the personality became instead scientific markers, the very elements that defined different forms of mental disorder. And the control of such symptoms, preferably by chemical means, became the new Holy Grail of the profession. Meanwhile, the public learned to

think of madness, not in terms of refrigerator mothers and sex, but as the product of faulty brain biochemistry, bad genes, or neurotransmitters gone haywire, with adjustments of surpluses or shortfalls of internal body chemistry the royal road to happiness and cognitive health.

Like all revolutions, although this series of dramatic changes seemed to materialize all at once, it had much deeper historical roots. The sudden loss of its institutional and intellectual dominance reflected some strategic errors and miscalculations on the part of the psychoanalytic community, but also the unplanned and unintended consequences of a whole series of other developments that dated back to the late 1940s and early 1950s, the era when the analysts first began to entrench themselves at the head of the profession of psychiatry. With its commitment to the analytic paradigm, American psychiatry had been at odds with the more eclectic mix of biological and social psychiatry that was typical almost everywhere else, but the revolutionary transformations that occurred in the United States in the last quarter of the 20th century would all but eliminate these national differences, and in short order produce the Americanization of world psychiatry. The definitions and treatments of madness launched by the American Psychiatric Association and underwritten by Big Pharma, the multinational pharmaceutical industry, whatever their limitations and problems, would triumph everywhere.

The post-war rise of psychoanalysis formed part of, and helped to produce, a massive shift in the social location of most psychiatric practice. In 1940, all but a tiny minority of psychiatrists worked in institutional settings. But as early as 1947, in a remarkable break from these pre-war precedents, more than half of all American psychiatrists worked in private practice or in out-patient clinics. By 1958, as few as 16% plied their trade in traditional state hospitals. Moreover, this rapid shift in the profession's centre of gravity occurred in the context of an extraordinary expansion in the

absolute size of the profession, which multiplied more than five-fold in the space of three decades. Not just the professional elite, but also most of the rank and file had thus abandoned the most severely mentally disturbed to their fate within fifteen years of the end of the war. And yet traditional mental hospitals loomed as large as ever on the American scene, as they did elsewhere in the developed world. In 1903, state and county asylums had contained 150,000 inmates on an average day. That number had grown to 445,000 in 1940, and had peaked at 559,000 in 1955, before falling back slightly to a total of some 535,500 in 1960. While the general population had doubled, the number of psychiatric inmates had quadrupled. Moreover, a steadily greater fraction of the whole was made up of chronic and especially elderly patients. In Massachusetts, for example, supposedly in the vanguard of psychiatric progress, almost 80% of the state mental hospital population had been institutionalized for five years or more by the 1930s. These hundreds of thousands of psychotics were left to the tender mercies of the dregs of the psychiatric profession, many of them foreign-born and foreign-educated, and barely capable of communicating in English. And they remained crammed into the decaying relics of the Victorian enthusiasm for incarcerating the mad. Helpless, hopeless, and highly stigmatized, this institutionalized population that presumably remained at the core of psychiatry's claims to expertise was increasingly treated as an embarrassment, something that the more 'progressive' elements of the profession were anxious to leave behind. Ironically, though, it was within this alienated social space that a revolution was brewing, one that would prompt the development of new ideological understandings of the nature, sources, and proper management of the mad; and would play some role (though not the role that conventional wisdom would have us believe) in the virtual disappearance of the asylum as the first line of response to the problems of grave and persistent mental disturbance.

No-one expected that this would be the case when a few employees of the then-obscure French drug company Rhône

Poulenc began to experiment in the late 1940s with a chemical compound, chlorpromazine, that had first been synthesized in a German laboratory in the late 19th century. The pharmaceutical industry was then far from occupying its powerful current place in the medical-industrial complex, but the standardization of 'ethical' drug manufacture (as opposed to the older patent-medicine industry) had been given an enormous stimulus by the discovery of the sulfa drugs and then by the advent of penicillin, a genuine magic bullet that could be employed against infectious diseases, and the race was on to discover other therapeutic compounds from which the industry could derive profits. Chlorpromazine was one such. It was an anti-histamine, a class of drugs that produced drowsiness, among other properties, and Rhône Poulenc thought it might have its uses as an anaesthetic potentiator. Anaesthetics are poisons, whose administration produces unpleasant side effects in many patients exposed to them (though most of us are extremely grateful to trade those side effects for relief from excruciating pain while we undergo surgery). So anything that could help reduce the amount of anaesthetic one required could prove medically desirable.

It was an attractive hypothesis, but a clinical failure. Undeterred, Rhône Poulenc sought other possible uses for the product. Perhaps it might be useful as a treatment for itchy skin, or as an anti-emetic, to control nausea and vomiting? Or it might serve as a general sedative. Trials were run along these lines, and supplies of the drug were made available quite freely to physicians who wanted to experiment with them. And thus a serendipitous discovery came to be made.

Drugs had previously been used in psychiatry. Some 19th-century psychiatrists had experimented with giving their patients marihuana, though most soon abandoned the practice. Opium had been mobilized as a soporific in cases of mania. Later on in the 19th century, chloral hydrate and the bromides had had their enthusiasts (though bromides in excess produced psychotic

symptoms, and their widespread use outside the asylum produced toxic reactions that landed substantial numbers of patients in mental hospitals, diagnosed as mad; and chloral, though effective as a sedative, was addicting, and with long-term use led to hallucinations and symptoms akin to delirium tremens). Lithium salts seemed to calm the agitation of manic patients, and some hydrotherapeutic establishments used them in the treatment of their nervous patients. But lithium could easily prove toxic, producing anorexia, depression, even cardiovascular collapse and death. (Its value would later be championed by the Australian psychiatrist John Cade after the Second World War, and the existence of calming effects in mania would prompt some continuing clinical interest in these compounds in Europe and North America. Their use would spread, but only to a degree, for lithium could not be patented, and hence was of minimal interest to the pharmaceutical industry and its marketing machine.) The 1920s had seen experiments with barbiturates, including attempts to place mental patients in chemically induced periods of suspended animation in the hopes that this would produce a cure. But barbiturates, too, had major drawbacks: they were addicting, overdoses could easily prove fatal, and withdrawal symptoms when they were discontinued were highly unpleasant, even dangerous. Besides, like the earlier drugs used by psychiatrists, their use produced mental confusion, impaired judgement, and inability to concentrate, as well as a whole spectrum of physical problems.

But when given to psychotic patients, chlorpromazine seemed to be different. It reduced florid symptomatology, and calmed patients down, producing an indifference that some observers at the time likened to a 'chemical lobotomy' – then seen as a positive development – but it did not seem to be addictive, or to have many of the other negative effects so prominent when other drugs were given to mental patients. Rhône Poulenc by now had sold the North American rights to the drug to Smith, Kline, and French, who labelled the compound Thorazine. (In Europe, it was originally called Largactil, or 'mighty drug', in recognition of what

was hoped to be its broad range of therapeutic applications.) In the early 1950s, Smith, Kline, and French had also explored a broad range of potential therapeutic applications for the drug, though none produced results likely to prove persuasive with the Food and Drug Administration. Except for the treatment of mental patients, the last application it tried, after the other options had proved disappointing.

The early studies on mental patients were easy to conduct. The patients were quite literally captive, and without civil rights. The notion of informed consent, let alone outside scrutiny of research protocols, was non-existent, and trials were easily set up, though virtually none of them employed research designs that by modern standards produced reliable knowledge. Rarely were control groups employed, and the experimenter was always aware of which patients were receiving the active compounds. The numbers of patients treated were often small, and criteria for assessing 'improvement' primitive and unreliable, and easily manipulable. The clinicians were uniformly convinced that they were on to something. At the end of 1953, however, a mere five months before it was to be marketed, Thorazine had been tested on a total of only 104 psychiatric patients in North America. Thirteen months later, it was being given to an estimated two million patients in the United States alone. By 1970, US pharmaceutical houses sold over a half billion dollars of psychiatric drugs, of which phenothiazines as a class accounted for more than $110 million. In a pattern that would become familiar in the drug industry, each of Smith, Kline, and French's competitors rushed to develop marginally different versions of the original drug that they could patent as their own.

Initially, psychoanalytically trained practitioners were inclined to ignore the new so-called anti-psychotic drugs on the grounds that they treated only the symptoms, not the underlying causes of mental disturbance. Subsequently, as it became more difficult to ignore these new interventions, they adopted a subtly different

To control agitation—a symptom that cuts across diagnostic categories

Thorazine®, a fundamental drug in
brand of chlorpromazine
psychiatry—Because of its sedative effect, 'Thorazine' is especially useful in controlling hyperactivity, irritability and hostility. And because 'Thorazine' calms without clouding consciousness, the patient on 'Thorazine' usually becomes more sociable and more receptive to psychotherapy.

leaders in psychopharmaceutical research **SMITH KLINE & FRENCH**

stance: the drugs were useful, but only in reducing surface symptomatology. The real contribution of drug treatment, they argued, was that it made the patients more accessible to analytic treatment, where the serious work of dealing with the underlying issues took place. Others, however, within and outside the psychiatric profession, drew the philosophically indefensible but understandable conclusion that if drugs which acted on the body modified the symptoms of psychiatric disorders, those disorders must surely be rooted in biology. Over time, this reasoning underpinned a move back to a biologically reductionist view of mental illness.

Freudian psychiatrists had always treated diagnostic categories as largely irrelevant, since what mattered were the complexities of the individual's personality and psychopathology. But as drug development proceeded, the need to standardize the patient population on which new drugs were tested became more pressing, and as new drugs seemed to have an effect on some, but not all, psychiatric patients, it became commercially attractive to try to distinguish different sub-populations among the mad for whom particular families of drugs seemed to work. For the profession as a whole, as increased attention came to be focused on diagnosis, the embarrassment that flowed from the profession's demonstrable inability to agree on what ailed a particular patient grew less and less tolerable, particularly as outsiders such as

16. Thorazine, or chlorpromazine (marketed in Europe, where it was first synthesized, as Largactil), was the first of the new so-called anti-psychotic, or neuroleptic, drugs. It was approved by the United States Food and Drug Administration in 1954, and a decade later had been administered to an estimated 50 million people worldwide, an astonishing marketing success fuelled in substantial measure by advertisements like this one, taken from the pages of the journal *Mental Hospitals*, which was published by the American Psychiatric Association

lawyers, psychologists, and sociologists used these disagreements to suggest that the psychiatric emperor had no clothes.

Within psychiatry, therefore, a vocal minority began to agitate for a reform of the diagnostic process, one that would standardize labels and categories to ensure maximum agreement between individual psychiatrists, something technically referred to as diagnostic reliability. In essence, this was a call for reviving the sort of descriptive psychopathology pioneered by Emil Kraepelin, and the movement to systematize psychiatric diagnoses is often referred to as 'neo-Kraepelinian'. It was an endeavour the psychoanalysts had little interest in, and by and large, they distanced themselves from the process. When the American Psychiatric Association convened a Task Force to revise the profession's *Diagnostic and Statistical Manual*, the analysts made minimal efforts to participate in or influence its deliberations. It would prove, in combination with psychoanalysis's earlier decision to keep their training institutes separate from university medical schools (diluting their influence in this crucial arena), to be a fatal mistake.

In 1980, when the third edition of the *Diagnostic and Statistical Manual* appeared, the speculative Freudian aetiologies for various forms of mental illness had vanished. Last-minute protests from analysts preserved the term 'neurosis', but it was a Pyrrhic victory, for it survived only in parentheses, and would be expunged altogether from the official nomenclature of mental disorder within a very few years. The 'surface' manifestations of mental diseases that the psychoanalysts had long dismissed as merely the symptoms of the underlying psychodynamic disorders of the personality became instead scientific markers, the very elements that defined different forms of mental disorder. And the control of such symptoms, preferably by chemical means, became the new Holy Grail of the profession.

It was a counter-revolution launched, not from the hallowed and ivied halls of the Harvards and Yales of this world, but of all places

from St Louis, by then marginal figures at the Washington University Medical School, and by a renegade Columbia psychiatrist, Robert Spitzer. And its primary weapon was a book, or rather an anti-intellectual system published in book form: a check-list approach to psychiatric diagnosis and treatment that sought maximum inter-rater reliability among psychiatrists confronted by a given patient, with scant regard for whether the new labels that proliferated in its pages cut nature at the joints. Agreement among professionals was enough, particularly on those occasions on which a given diagnosis could be linked to treatment with a particular class of drugs. Indeed, soon enough the polarity would be reversed, and the creation of a new class of drugs would lead to the creation of a new psychiatric 'disease' to match, just one of the factors that prompted successive editions of the *Diagnostic and Statistical Manual* to proliferate pages and disorders, like the Yellow Pages on steroids. The scarcely used DSM-II, published in 1968, had recognized a mere 182 different psychiatric disorders. When DSM-III appeared in 1980, this had risen to 265, and by the time another major revision, DSM-IV, appeared in 1994, there were 297 different diagnoses listed. The number of psychiatric illnesses metastasized despite the disappearance of a number of 'mental illnesses' like homosexuality and hysteria from the official psychiatric lexicon during the last two decades of the 20th century. The profits available from new classes of drugs, however trivial the differences that marked them off from existing compounds, encouraged the transformation of all sorts of daily distress and the ordinary vicissitudes of human existence into new 'diseases' allegedly caused by 'chemical imbalances', all resting on the apparent authority of science, but in reality on purely circular reasoning.

The eclipse of psychoanalysis, the lurch back to biological accounts of madness, and the rapid growth of psychopharmacology were not the only dramatic changes in the psychiatric landscape that marked the last four decades of the 20th century. From the Victorian age until the dawn of the 1960s,

most of the Bedlam mad could expect a prolonged period of confinement inside one of the warehouses of the unwanted whose distinctive buildings for so long haunted the countryside, and provided mute testimony to the emergence of segregative responses to the management of mental illness. Nowadays, such encounters with the physicality of mass segregation and confinement, and with the peculiar moral architecture which the Victorians constructed to exhibit and contain the dissolute and the degenerate, are increasingly fugitive and fast fading from the realm of possibility. For the other component of the revolutionary changes that enveloped Western responses to mental illness in the closing decades of the last century was the increasingly precipitous abandonment of the bricks and mortar approach, with some mental hospitals simply left to moulder away, and others, irony of ironies, converted into luxury housing for yuppies, their developers taking care to coyly disguise their stigmatizing past. Deinstitutionalization, or decarceration as an alternative ugly neologism had it, was the order of the day. In their tens and even hundreds of thousands, mental patients were discharged from traditional mental hospitals (or refused admission in the first place), and instead consigned to the not-so-tender mercies of treatment in the 'community'.

The transformation this entailed began slowly, uncertainly, and unevenly. Mental hospital censuses had risen almost uninterruptedly for more than a century, and even in England and the United States, where the reversal began, its significance was unclear at first, and it was uncertain whether it would persist. In England, the numbers under confinement peaked in 1954 at 148,100, and fell by fewer than 12,000 by 1960. In the United States, the national decline began a year later, after the census reached a maximum of 558,900, and had fallen to 535,500 in 1960. Thereafter, however, the pace of change accelerated markedly, and the pattern eventually spread to countries like France, Spain, and Italy, where commitment to the old asylum-based approach had lasted longer. By century's end, the

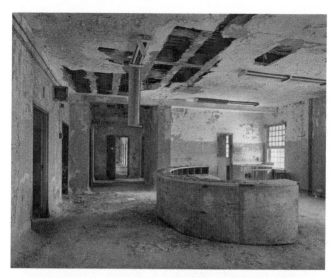

17. The central nurses' station at Milledgeville State Hospital. Once housing a community of upwards of 14,000 staff and inmates, the fate of its buildings mirrors that of many of the vast bins that once housed legions of lunatics

abandonment of the asylum was visible all across Europe and North America. In Italy, led by the charismatic Franco Bassaglia, the political left led the charge. Places like the old asylum for women on San Clemente Island in the Venice lagoon were shuttered, in this case re-opening as a hotel offering a luxurious refuge from the crowds thronging the city, its owners boasting of its past as a monastery, while gliding silently over its less salubrious and more recent role. In California, decarceration was a project of the Reaganite right, led by the grand old man himself, who promised to shut down 'superfluous' institutions, and on this occasion actually tried to follow through on his rhetoric. In England, Enoch Powell, minister of health in the Macmillan government, not yet consigned to the political wilderness for his views on race and immigration, employed characteristically blunt

language, promising to err 'on the side of ruthlessness' and to 'set the torch to the [mental hospital's] funeral pyre'. The Thatcherite and Blairite regimes would pursue the path he had spelled out with equal enthusiasm, as would both Republican and Democratic administrations in Washington and in the individual states. The consensus on the desirability of community care has become as overwhelming as the Victorians' convictions about the merits of the asylum.

If success is defined as driving down in-patient populations, even in the face of rising admissions into the mental health sector, then decarceration has been an unambiguous triumph. The reputation of the traditional mental hospital had been so blackened by journalists, sociologists, Hollywood film makers, and even many of the psychiatric profession, that 'community care' has been easily seen as an unambiguous blessing. For some patients, capable of functioning reasonably successfully in the outside world, and perhaps among those who respond relatively well when treated with the new generations of drugs, that has certainly been the case. But for many more, closer scrutiny suggests a very different verdict is warranted.

Our contemporary techniques of containment and damage limitation when it comes to the severely and chronically mentally ill mimic in many respects the place of insanity in the 18th century. Many psychiatric casualties have been thrust back into the arms of their families. Here, largely bereft of official support or subsidy, unpaid carers (usually female) are left to cope as best they can. These burdens are massive, and ultimately, for many families, simply intolerable. As Erving Goffman (known to most only as a critic of asylums) once summarized the case, 'the compensative work required by the well members [of the family] may well cost them the life chances their peers enjoy, blunt their personal careers, paint their lives with tragedy, and turn all their feelings to bitterness'. So it has proved. The state has systematically failed to build up the infrastructure of services and financial supports

essential for any workable system of community care, which has become, in the words of Sir Roy Griffiths, in an official survey of British practice, 'a poor relation: everybody's distant relative, but nobody's baby'.

Families for the most part cannot or will not absorb all of the burdens the new policies impose, particularly over the long haul, and so examination of the place of insanity in our own era must look also to the sidewalk psychotic (now a familiar feature of most urban landscapes), the boarding house, and the gaol to grasp the range of our current provision (or lack of provision) for the mentally ill. In California, for instance, prisons and gaols have become the single largest purveyors of mental health care. More generally, the board and care industry in the United States has made a substantial living from speculating in this form of misery, taking the welfare payments now available to some of the mentally disabled and developing a network of private institutions that form an analogue of the 18th-century trade in lunacy. For thousands of the old, already suffering in varying degrees from mental confusion and deterioration, deinstitutionalization has meant premature death. For others, it has meant that they have been left to rot and decay, physically and otherwise, in broken-down welfare hotels or in what are termed, with Orwellian euphemism, 'personal care' nursing homes. For thousands of younger psychotics discharged into the streets, it has meant a nightmare existence in the blighted centres of our cities, amidst neighbourhoods crowded with prostitutes, ex-felons, addicts, alcoholics, and the other human rejects now repressively tolerated by our society.

Some have suggested that the discharge of all these patients was simply the product of the new technological fix psychotropic drugs provided for the problems posed by mental illness. There was, after all, a temporal coincidence between the marketing of the phenothiazines and the decline in overall in-patient numbers in Britain and the United States; and psychiatrists, whose role in

treating the chronically mentally ill has mostly shrunk to the writing of prescriptions for these pills, have mostly embraced this simplistic account. Assuredly, anti-psychotic medications have played some role in the process. Thorazine and its derivatives gave psychiatry for the first time a therapeutic modality that was easy to dispense and closely resembled the magic potions that increasingly underpinned the cultural authority of medicine at large. Too bad that the phenothiazines were no psychiatric penicillin, and indeed that they would be responsible for a massive and long-ignored epidemic of iatrogenic illness. They reduced florid symptomatology, and for some patients, at least, provided a measure of relief. After centuries of therapeutic impotence, it was perhaps understandable that the psychiatric profession was so grateful for their arrival and so eager to hype the value of the new pills.

In truth, the anti-psychotics played at best a secondary role in the demise of the asylum. Patient compliance with doctors' orders is a serious problem even among the sane. Getting psychotics to keep taking their drugs is even more problematic, particularly when they experience unpleasant side effects: loss of spontaneity, severe reductions of motor activity, devastating and stigmatizing neurological side effects (an issue to which I shall return). Then, too, while some patients obtain symptomatic relief while on medication (though that degree of improvement tends to decline over time), a very large fraction – well over 50% – do not obtain even this benefit from their drugs. The early uncontrolled trials that claimed to demonstrate the value of the drugs systematically overstated their usefulness, and it has become steadily more apparent that the therapeutic effectiveness of so-called anti-psychotic drugs has been grossly oversold. In many jurisdictions, mental hospital censuses had begun to decline years before the introduction of the phenothiazines, and careful analysis by an array of scholars who have troubled to look at the available evidence has not shown any clear connection between the introduction of the drugs and deinstitutionalization. Decarceration

was driven far more by fiscal concerns – the massive costs of running and replacing the traditional mental hospitals, and the ability of state governments in America to transfer mental health costs to the federal government and to local authorities by turning patients out of state-run facilities – and by conscious shifts in state policy such as tightened commitment laws.

For the pharmaceutical industry, psychiatric drugs were a bonanza, a major source of profits that ran into many billions of dollars. Almost instantly alive to the profit potential of the phenothiazines, drug companies soon began to market another class of psychoactive drugs, the so-called minor tranquillizers. Miltown and Equanil (meprobamate), which made users drowsy, and later on Valium and Librium (the benzodiazapines), which didn't. The troubles of everyday life were effortlessly redefined as psychiatric illnesses. Here were the pills that proffered a solution to the boredom of the trapped housewife, the blues of overwhelmed mothers and of the fading middle-aged. The Rolling Stones sang sarcastically about 'mother's little helper', and a generation of the young raided the family medicine cabinet in search of the happy pills. As early as 1956, statistics suggest that as many as one American in twenty was taking tranquillizers in any given month. Anxiety, tension, unhappiness, all could be smoothed away by medication. Or so some thought. But inevitably, there was a price to be paid. Actually more than one. Constricting the normal range of human emotion, and running from life's challenges into a chemical fog, might have a short-term appeal, but steadily truncated one's capacity to cope and diminished one's ability to function as an autonomous adult. And those taking the drugs became physically habituated to them, till they found it difficult or impossible not to continue using them, for to abandon the pills was to court symptoms and psychic pain worse than those that had driven the decision to use them in the first place. Tranquillizers, in the eyes of a growing number of critics, were as much a problem as a solution, helping those ingesting them along their way to their 'busy dying day', as the

Stones memorably phrased it. By the mid-1970s, in many countries Valium was the single most prescribed drug, but simultaneously growing concerns about its addictive properties were shadowing its use.

The multi-nationals were slower to recognize the similarly large rewards that could flow from exploiting compounds that changed other aspects of people's moods. A variety of drugs that had some effect on depression had begun to surface from the late 1950s onwards, beginning with Iproniazid, a monoamine oxidase inhibitor, in 1957, and Trofranil and Elavil, so-called tricyclic anti-depressants, in 1958 and 1961 respectively. Perhaps in part because many depressed people suffer in silence, the belief persisted that depression was a comparatively rare condition, and drug companies such as Geigy and Roche, given the opportunity to introduce these drugs, dragged their heels about marketing them. Hypertension, they were convinced, was a far larger market than depression. The belated success of Prozac changed that mindset completely. And changed as well both the professional and the public's understanding of mental disorder. Depression was now a disease of epidemic proportions, one every drug company wanted a piece of.

The US National Institute of Mental Health proclaimed the 1990s 'the decade of the brain'. A simplistic biological reductionism increasingly became the dominant psychiatric paradigm (ironically exhibiting some parallels with the biological reductionism of a century earlier, when psychiatrists had proclaimed that the mad were 'tainted creatures', doomed to permanent insanity by the defects of their degenerate, inherited germ plasm). Patients and their families learned to attribute mental illness to faulty brain biochemistry – defects of dopamine or a shortage of seratonin. It was biobabble as deeply misleading and unscientific as the psychobabble it replaced, but as marketing copy it was priceless. Biological reductionism of this sort had a particularly powerful attraction for an increasingly important

segment of those affected by the scourge of major mental illness, the parents and other family members of the mental patient. Where the theories of the psychoanalysts had blamed the pathologies of family life, and especially the depredations of the 'refrigerator mother', for the creation of psychosis, biological accounts of mental illness stressed that madness was an illness like any other. If biochemical imbalances and neurotransmitter defects were the root of the problem, then families were absolved of all blame or responsibility. And if madness was rooted in biology, then surely drugs rather than talk were the appropriate response, since chemicals could alter the internal physiological environment. In embracing biology, family members were thus prime candidates to speak out on the merits of drug treatment, and they have indeed become vocal advocates for the new somaticism. The drug industry has welcomed their support and done much to help to publicize their views. For example, Senator Grassley's subcommittee of the US Senate's Finance Committee found that industry subsidies provided as much as 75% of the budget of the National Alliance on Mental Illness, the largest and most prominent organization of activist family members.

Meanwhile, the psychiatric profession itself has been in receipt of massive quantities of research funding from the pharmaceutical industry. Where once psychiatrists had been the most marginal of specialists, existing in a twilight zone on the margins of professional respectability (their talk cures and obsessions with childhood sexuality only amplifying the scorn with which most mainstream doctors viewed them), now they were the darlings of medical school deans, the millions upon millions of their grants and indirect cost recoveries helping to finance the expansion of the medical-industrial complex. The pharmaceutical industry has become the most profitable industrial sector on the planet (in 2002, for example, the profits of the ten largest pharmaceutical houses exceeded the total combined profits of the remaining 490 corporations making up the Fortune 500 list). And a large slice of its profits have derived from the pills directed at mental illness.

In 2008, for example, the most recent year for which we have data, anti-psychotics ranked as the single largest source of revenue among all classes of drugs, accounting for $14.6 billion, or 5% of all expenditures for pharmaceuticals in the United States, by far the most lucrative market in the world; and anti-depressants that same year ranked fifth, accounting for $9.6 billion in sales.

To a quite extraordinary extent, drug money has come to dominate psychiatry. It underwrites psychiatric journals and psychiatric conferences, where the omnipresence of pharmaceutical influence startles the naïve outsider. It makes or mars psychiatric careers through granting or withholding research support. At an even more fundamental level, the very categories within which we think about cognitive and emotional troubles are in flux, and the changes imported into psychiatry's diagnostic categories seem to many critics to correspond more closely to the marketing needs of the pharmaceutical houses than to advances in basic science.

Writers of this persuasion have been harshly critical of many features of modern psychiatry. They have pointed out, for example, that many of the most generously funded academic psychiatrists have elected to promote lucrative off-label uses for drugs whose initial approval for prescription was awarded on quite other grounds. Following on from the work of these critics, editorials in such major medical journals as the *Lancet*, the *Journal of the American Medical Association*, and the *New England Journal of Medicine* have acknowledged the problems of the misrepresentation of research data and of ghostwriters who produce peer-reviewed 'science' that surfaces in even the most prestigious journals, with the most eminent names in the field collaborating in the deception. Class-action lawsuits in the United States, and the inquiries of a subcommittee of the Senate Finance Committee, chaired by Senator Grassley, have shown that in a number of cases, researchers have been induced to sign confidentiality agreements, which ensure that inconvenient data have never seen the light of day.

Problems of this sort are not the peculiar province of psychiatry, as the Vioxx painkilling scandal and some of the evidence that surfaced in the course of the controversy over hormone replacement therapy (HRT) serve to remind us. In other respects, too, the situation with respect to psychiatric therapeutics has parallels with what we find in many non-psychiatric disorders, for which the most that modern medicine can offer is a measure of comfort and symptomatic relief. If, for some of those who suffer from the miseries madness brings in its train, anti-psychotics, anti-depressants, and anti-anxiety drugs provide similar advantages, we should not dismiss them out of hand. To speak as some have done of 'toxic psychiatry' and to suggest that all psychiatric drugs are a snare and a delusion, that they are simply poisons not therapy, is in my view irresponsible and misguided. But it is as well to understand the price this treatment exacts, and to weigh far more carefully than the psychiatric profession and the pharmaceutical industry would seem to have us do, the negative as well as the positive impact of the psychopharmacological revolution.

For twenty years after the introduction of Thorazine, for example, psychiatrists ignored or minimized the side effects that this class of drugs brought in its train. Substantial numbers of patients experience Parkinson-like symptoms: muscular rigidity, shuffling gait, loss of associated movements, and drooling. Others experience 'akithisia', constant pacing and an inability to keep still. As many as 15–25% of patients on long-term anti-psychotics develop tardive dyskinesia, characterized by sucking and smacking movements of the lips, rocking, and uncontrolled jerky movements of the extremities – behaviours that, ironically, the lay public often views as symptoms of mental illness – and these symptoms are often permanent, apparently the result of iatrogenic (drug-induced) neurological damage to the brain.

The mass marketing of Prozac and other anti-depressants in the 1990s saw the emergence of depression as 'the common cold' of

psychiatry, and the intensive selling of the idea that all sorts of fluctuations in mood were 'illnesses' amenable to chemical treatment. Particularly prominent were claims that these disorders were traceable to improper levels of seratonin, a neurotransmitter, in the brains of the afflicted – a scientifically discredited notion nonetheless seized upon by the drug marketers, and one responsible for transforming lay conceptions of these conditions. Drawing a hard-and-fast line between sanity and madness has always been a fraught business, and the temptations to expand the boundaries of the pathological have arisen as lucrative, easy-to-prescribe pills have made their appearance in the medical marketplace. 'Social phobia', for example, was first listed in *DSM-III* as a rarely encountered 'illness', but by the time the fourth edition appeared in 1994, psychiatrists suggested that it was afflicting as many as 10% of the population. From the patients' side of the equation, in some circles it has become almost fashionable to resort to mood-altering drugs, just as, in an earlier generation, some revelled in and boasted about prolonged sessions with their psychoanalysts.

The next edition of the Bible of biological psychiatry, the *Diagnostic and Statistical Manual*, is in preparation, and, at the time of writing, is slated to appear in 2013, although it is surrounded by some controversy. By all indications, it will further enlarge the realm of mental pathology. The current epidemic of autism, for example, will likely accelerate once the looser category of 'autism spectrum disorder' is promulgated. A newly proposed category of 'mixed anxiety depressive disorder' has such non-specific and widely distributed 'symptoms' that its creation would likely provoke yet another epidemic. So, too, one suspects, would proposals to sanctify 'temper dysfunctional disorder', or 'binge-eating disorder'. Likely to have even more profound effects is still another trial balloon that has been floated, something called 'psychiatric risk syndrome': a category which would allow early psychiatric intervention (presumably with drug treatments) based on a broad array of extraordinarily loosely defined 'symptoms' that

might (or might not) presage later mental illness. Allen Frances, chair of the task force that created *DSM-IV*, has warned that, if enacted, these proposed changes:

> would create tens of millions of newly misidentified false positive 'patients,' thus greatly exacerbating the problems already caused by an overly inclusive DSM-IV. There would be massive overtreatment with medications that are unnecessary, expensive, and often quite harmful… [and] the inclusion of many normal variants under the rubric of mental illness, with the result that the core concept of 'mental disorder' is greatly undermined.

What is remarkable about the expansion of the boundaries of mental disorder that has already occurred, let alone the further changes that loom on the horizon, is that, for all the massive expansion of neuroscientific research that the biological turn in psychiatry and the associated drugs revolution have funded, our knowledge of brain function remains in its infancy, and the aetiology of almost all forms of Bedlam madness remains as mysterious as ever. We simply don't know what the roots of schizophrenia or major depression are (periodic breathless proclamations to the contrary notwithstanding); and the therapeutics at our disposal remain strikingly limited, and are bought at a heavy price. One startling measure of the price patients pay that is seldom attended to, and yet is perhaps the most telling of all: in David Healy's words, 'Uniquely among major illnesses in the Western world, the life expectancy for patients with serious mental illness has declined.' This astonishing outcome is a product, ironically, of the metabolic effects of the newer generation of drugs, launched because they have patent protection and thus far higher profit margins: diabetes, massive weight gain, heart disease, and the like, which also have a strongly negative impact on patients' quality of life. Meanwhile, the social and psychological dimensions of mental disorder are wished away, or passed along to the cheaper and heavily feminized professions of clinical psychology and psychiatric social work to cope with.

Making matters worse, those afflicted with the most serious of mental ills find themselves cast out from even the limited and ambiguous degree of shelter and care once provided in the Victorian asylums. As for psychiatry, which for an interlude saw its major role as listening to patients, it now seems to prefer to listen to Prozac, as the title of a psychiatric best-seller would have it, and to dance to the seductive music played by the pharmaceutical industry. Thus the fate of madness at the beginning of the new millennium.

Further reading

Chapter 1: Madness unbound

Jonathan Andrews, Asa Briggs, Roy Porter, Penny Tucker, and
 Keir Waddington, *The History of Bethlem* (London: Routledge,
 1997). An up-to-date, collectively authored volume on the history
 of the English-speaking world's most famous asylum, from its
 medieval origins to the end of the 20th century.
Stanley W. Jackson, *Melancholia and Depression from Hippocratic
 Times to Modern Times* (New Haven: Yale University Press, 1986).
 A reliable synthesis.
James M. Longrigg, *Greek Rational Medicine* (London: Routledge,
 1993). A review of the tradition within which the ancients thought
 about mania and melancholia.
Vivian Nutton, *Ancient Medicine* (London: Routledge, 2004).
 A valuable overview of Western medicine in the classical period.
Bennett Simon, *Mind and Madness in Ancient Greece* (Ithaca: Cornell
 University Press, 1980). A stimulating overview.

Chapter 2: Madness in chains

Jonathan Andrews and Andrew Scull, *Undertaker of the Mind:
 John Monro and Mad-Doctoring in Eighteenth Century England*
 (Berkeley: University of California Press, 2001). A wide-ranging
 examination of the place of madness in 18th-century culture and
 society.
Max Byrd, *Visits to Bedlam: Madness and Literature in the Eighteenth
 Century* (Columbia: University of South Carolina Press, 1974).

George Cheyne, *The English Malady*, reprint edn., ed. Roy Porter (London: Routledge, 1991). Porter's editorial introduction provides useful perspective on a psychiatric classic.

Michael V. Deporte, *Nightmares and Hobbyhorses: Swift, Sterne, and Augustan Ideas of Madness* (San Marino, California: Huntingdon Library, 1974).

Michel Foucault, *Madness and Civilization: A History of Insanity in the Age of Reason* (London: Tavistock, 1971). An abbreviated translation of a highly controversial and widely influential revisionist interpretation of the place of madness in the West, which places particular emphasis on the 17th and 18th centuries, and more often than not uses France as a proxy for 'civilization'.

Richard Hunter and Ida Macalpine (eds.), *Three Hundred Years of Psychiatry, 1535–1860* (London: Oxford University Press, 1963). A remarkable anthology, with useful editorial introductions by the editors.

Michael MacDonald, *Mystical Bedlam: Madness, Anxiety, and Healing in Seventeenth Century England* (Cambridge: Cambridge University Press, 1981). A sophisticated and nuanced discussion.

Erik H. C. Midelfort, *A History of Madness in Sixteenth Century Germany* (Stanford: Stanford University Press, 1997).

Roy Porter, *Mind Forg'd Manacles: A History of Madness in England from the Restoration to the Regency* (London: Athlone, 1987). A typically high-spirited overview.

Duncan Salkeld, *Madness and Drama in the Age of Shakespeare* (Manchester: University of Manchester Press, 1993).

Chapter 3: Madness confined

Lisa Appignanesi, *Mad, Bad and Sad: A History of Women and the Mind-Doctors from 1800 to the Present* (London: Virago, 2008). A very readable recent interpretation of the intersections of gender, madness, and psychiatry.

Robert Castel, *The Regulation of Madness: The Origins of Incarceration in France* (Berkeley: University of California Press, 1988). An interpretation of the rise of the asylum by one of Foucault's circle.

Ian Dowbiggin, *Inheriting Madness: Professionalization and Psychiatric Knowledge in Nineteenth Century France* (Berkeley: University of California Press, 1991). The rise and influence of degeneration as an explanation of madness.

Jan Goldstein, *Console and Classify: The French Psychiatric Profession in the Nineteenth Century* (Chicago: University of Chicago Press, 2001). The politics of professionalization in 19th-century France.

David Rothman, *The Discovery of the Asylum: Social Order and Disorder in the New Republic* (Boston: Little, Brown, 1971). The rise of the asylum in the United States, viewed through the prism of social control.

Andrew Scull, *The Most Solitary of Afflictions: Madness and Society in Britain, 1700–1900* (London and New Haven: Yale University Press, 1993). The construction of museums of madness.

Andrew Scull, Nicholas Hervey, and Charlotte MacKenzie, *Masters of Bedlam: The Transformation of the Mad-Doctoring Trade* (Princeton: Princeton University Press, 1996). The creation of psychiatry in 19th-century Britain, examined through a series of linked biographies of major figures.

Akihito Suzuki, *Madness at Home: The Psychiatrist, the Patient, and the Family in England, 1820–1860* (Berkeley: University of California Press, 2006). Domestic care of the insane in the early years of the asylum era.

Nancy Tomes, *A Generous Confidence: Thomas Story Kirkbride and the Art of Asylum Keeping, 1840–1883* (Cambridge: Cambridge University Press, 1984). An impressive study of an American asylum for the upper classes, which usefully explores the perspectives of patients and their families.

Chapter 4: Madness and meaning

Joel Braslow, *Mental Ills and Bodily Cures: Psychiatric Treatment in the First Half of the Twentieth Century* (Berkeley: University of California Press, 1997). The use of a variety of somatic treatments for mental illness, seen through the prism of clinical practice in California's mental hospitals.

Eric J. Engstrom, *Clinical Psychiatry in Imperial Germany: A History of Psychiatric Practice* (Ithaca: Cornell University Press, 2004). A detailed and thoughtful examination of psychiatry in Germany from the mid-19th century to the First World War.

Nathan G. Hale, Jr, *Freud and the Americans: The Beginnings of Psychoanalysis in the United States, 1876–1917* (Oxford: Oxford University Press, 1971).

Nathan G. Hale, Jr, *The Rise and Crisis of Psychoanalysis in the United States: Freud and the Americans, 1917–1985* (Oxford:

Oxford University Press, 1995). A useful two-volume study by a psychoanalytic true believer.

George Makari, *Revolution in Mind: The Creation of Psychoanalysis* (New York: HarperCollins, 2008). A judicious, sympathetic, and wide-ranging examination of the rise of psychoanalysis through the mid-20th century.

Jack D. Pressman, *Last Resort: Psychosurgery and the Limits of Medicine* (Cambridge: Cambridge University Press, 1998). A sympathetic (perhaps overly sympathetic) reinterpretation of the place of lobotomy in the history of psychiatry.

Andrew Scull, *Madhouse: A Tragic Tale of Megalomania and Modern Medicine* (London and New Haven: Yale University Press, 2005). The vulnerability of the mad to therapeutic enthusiasms.

Andrew Scull, *Hysteria: The Biography* (Oxford: Oxford University Press, 2009). A history of a controversial, now officially defunct, disorder on the borderlands of madness.

Chapter 5: Madness denied

Albert Deutsch, *The Shame of the States* (New York: Harcourt, Brace, 1948). The classic journalistic indictment of America's mental hospitals in the years following the Second World War.

Bruce Ennis and Thomas Litwack, 'Psychiatry and the Presumption of Expertise: Flipping Coins in the Courtroom', *California Law Review*, 62 (1974): 693–752. A highly critical survey by two lawyers of the literature on the reliability of psychiatric diagnoses.

Erving Goffman, *Asylums* (Garden City, New York: Anchor Books, 1961). The famous analysis of the mental hospital as a total institution.

Ken Kesey, *One Flew Over the Cuckoo's Nest* (New York: Viking, 1962). The counter-cultural critique of psychiatry in the form of a best-selling novel, later a famous film.

Ronald D. Laing, *The Divided Self* (Harmondsworth: Penguin, 1960).

Ronald D. Laing and Aaron Esterson, *Sanity, Madness and the Family* (Harmondsworth: Penguin, 1964). The books that made R. D. Laing a sixties' guru.

Paul Lerner, *Hysterical Men: War, Psychiatry, and the Politics of Trauma in Germany, 1890–1930* (Ithaca: Cornell University Press, 2003). Shell shock from the German perspective.

David Rosenhan, 'On Being Sane in Insane Places', *Science*, 179, 19 January 1973: 250–8. A famous social psychological experiment

that heightened concerns about the reliability of psychiatric diagnoses, and provoked fury among the psychiatric profession.

Thomas J. Scheff, *Being Mentally Ill* (Chicago: Aldine, 1966). The *locus classicus* of the sociological claim that mental illness was all a matter of labelling.

Ben Shephard, *A War of Nerves: Soldiers and Psychiatrists, 1914–1994* (London: Pimlico Books, 2002). The best single treatment of its subject.

Thomas Szasz, *The Myth of Mental Illness* (New York: Hoeber, 1961). The Ur-text of the anti-psychiatry movement.

Chapter 6: Madness cast out

Catherine D. DeAmgelis and Philip B. Fontanarosa, 'Impugning the Integrity of Medical Science: The Adverse Effects of Industry Influence', *Journal of the American Medical Association*, 299 (2008): 1833–5. Commentary on data manipulation and misrepresentation by the pharmaceutical industry and its allies.

Allen Frances, 'Opening Pandora's Box: The 19 Worst Suggestions for DSM-5', *Psychiatric Times*, 27 (2), 11 February 2010. Critical commentary on the potential consequences of changes in the next edition of the *Diagnostical and Statistical Manual* for the diagnosis of mental illness.

Gerald Grob, *From Asylum to Community: Mental Health Policy in Modern America* (Princeton: Princeton University Press, 1991). A history of deinstitutionalization in the United States that largely glosses over its problematic impact.

David Healy, *The Anti-Depressant Era* (Cambridge, Massachusetts: Harvard University Press, 1997). A major study of the psychopharmacological revolution.

David Healy, *Mania: A Short History of Bipolar Disorder* (Baltimore: Johns Hopkins University Press, 2008). Psychiatry, Big Pharma, and the reconstruction of mental illness.

Herb Kutchins and S. A. Kirk, *Making Us Crazy: The Psychiatric Bible and the Creation of Mental Disorders* (New York: Free Press, 1997). An examination of the construction of the third edition of the Diagnostic and Statistical Manual of the American Psychiatric Association, the decisive event in the rise of neo-Kraepelinian psychiatry.

C. Seth Landefeld and Michael A. Steinman, 'The Neurontin Legacy: Marketing through Misinformation and Manipulation',

New England Journal of Medicine, 360 (2009): 103–6.
An example of the kinds of deceit practised by the pharmaceutical
industry as exposed by class action litigation, here including
techniques for 'off-label' marketing of a drug for treatment of
'bi-polar' disorder.

Andrew Scull, *Decarceration: Community Treatment and the Deviant*
(Englewood Cliffs, New Jersey: Prentice-Hall, 1977). An early
critical examination of the emptying of mental hospitals.

Judith Swazey, *Chlorpromazine and Psychiatry* (Cambridge,
Massachusetts: MIT Press, 1974). A useful, if flawed, history of the
introduction of the first 'anti-psychotic' drug, Thorazine.

Index

Index